STAGECOACHING

ON THE CALIFORNIA COAST

The Coast Line Stage

⤙⤚ from ⤙⤚

Los Angeles to San Juan

Maury Hoag

2001
FITHIAN PRESS
SANTA BARBARA, CALIFORNIA

Published by Fithian Press
A division of Daniel and Daniel, Publishers, Inc.
Post Office Box 1525
Santa Barbara, CA 93102
www.danielpublishing.com

LIBRARY OF CONGRESS CATALOGING-IN-PUBLICATION DATA
Hoag, Maury (date)
 Stagecoacing on the California coast : The Coast Line Stage from Los
Angeles to San Juan / by Maury Hoag.
 p. cm.
Includes bibliographical references.
 ISBN 1-56474-353-5 (alk. paper)
 1. Coaching—California—History. 2 Coast Line Stage Company—
History. 3. California—Description and travel. 4 California—History—
1850–1950. I. Title
 HE5748.C2 H63 2001
 388.3'228'09794—dc21 00-009281

Stagecoaching on the California Coast

This book is dedicated to
ORVILLE HOAG,
my father, who was always going to write
the Great American Novel

and my mother,
ZELA HOAG,
who taught me that all things are possible.

To those persons too numerous to name who gave
inspiration, ideas, and knowledge:
without your help this book would not have been possible.

Contents

Stagecoaching on the California Coast

⊰ Introduction ⊱

Stagecoaching Comes to the California Coast

Before the Gold Rush, most transportation to and from California was by sailing ship. People coming from the East Coast came by ship around Cape Horn or came by way of Panama, where they had to traverse the rugged Isthmus by foot. A few brave souls crossed the plains in covered wagons, a far more difficult way to reach the the West. It wasn't until 1857 that the Overland Stage Line was established from San Diego to San Antonio, Texas.

Once they got to California, people still found it difficult to get around.

The "Yankee Blade," shipwrecked off Point Arguello in 1854, was typical of steamers that traveled up and down the Pacific coast during the stagecoach period.

Lompoc Historical Society

Those who wanted to go from Los Angeles to San Francisco or any other place along the California coast did so by ship; steamships were the main means of sea travel by the 1850s. There were no roads along the coast at that time, other than the horseback trails that had been used since the time of Portolá.

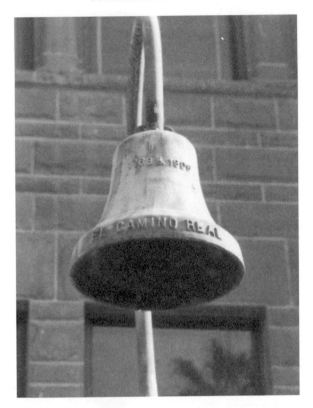

These replicas of mission bells have been placed along California highways to designate the path of the padres to each of the California missions, the original El Camino Real. This was also the basic route of the Coast Line Stage Company.

Change became necessary with the Gold Rush, especially because of the increased need for communication and mail delivery. The stagecoach was the obvious solution. Stagecoaching had been successful for years in the East and was a natural for California. Wells Fargo and others quickly developed safe mail and gold delivery between the gold fields and San Francisco. It wasn't long before stage service went south from San Francisco as far as San Jose. Records show that a branch of the San Jose Line extended to Natividad, in Monterey County, as early as 1851.

The development of stagecoaching in Southern California was not as rapid. Until the early 1860s most stage travel in the south was between Los Angeles and San Pedro, serving as a connection to the ships. At that time there were still no suitable roads up and down the coast, as overland coastal travel was considered too treacherous. Rivers, from the Salinas in Monterey County in the north to the Santa Clara in Ventura County in the south, posed a serious problem; they were dry most of the year, but in the rainy season they swelled to raging torrents as wide as a mile, and they stayed that way for days, or even weeks. Also, there were mountains that ringed Los Angeles, leaving few ways out of the San Fernando Valley.

The first mail service up and down the California coast was supplied by the military. Soldiers on horseback rode north from San Diego and south from San Francisco. They would travel as far as Nipomo from either direction, drop their mail there, pick up the return mail, and go back the way they had come, delivering mail as they went. This system worked amazingly well from 1849 until 1862.

Stagecoach travel between Los Angeles and San Francisco started in 1857, but it was not along the coast. As early as 1854, Phinneas Banning had driven one of his San Pedro Line stages from Fort Tejon through what is now Tejon Pass to prove that large vehicles could be taken out of San Fernando Valley. The trip was rough-and-tumble and almost demolished the coach. However, he did prove his point, and in 1857, the U.S. Army developed Fort Tejon and put a road through, establishing the Tejon Pass and making it possible for the Butterfield Stage Lines to reach the central valley. Butterfield had the first contract with the U.S. Government to develop a national stagecoach network for mail and passenger distribution. They were thus the first to offer passenger stagecoach service between Los Angeles and San Francisco. The route went from Los Angeles to the central valley via the Tejon Pass, then back across the Pacheco Pass to Gilroy, and then on to San Francisco.

In 1859, the city fathers of Los Angeles sent General Ezra Drown to Santa Barbara to discuss the construction of a road from Los Angeles through Santa Barbara to San Luis Obispo. Ventura County did not exist at that time, and Santa Barbara County bordered on Los Angeles County. Drown must have been successful, because the following year James Thompson of Los Angeles contracted for the construction of a new road to Santa Barbara and beyond, passing through the cities of Ventura and Santa Barbara to San Luis Obispo, by way of Gaviota Pass, a total distance of about 225 miles. This project took many months of rough work and cost over thirty thousand dollars.

In 1862, "good roads" were completed all the way from Los Angeles to San Juan Bautista, leaving the San Fernando Valley by way of the Conejo Pass. Regular stage service began by Overland Stage, a branch of the Butterfield line. When the Gaviota Pass was widened and the Conejo Grade developed, the Conejo stage road became a viable transportation system across the San Fernando Valley and out of the valley north. At this point, the U.S. Government felt compelled to begin mail service up and down the coast by land instead of by sea, and by stagecoach instead of by military riders. Several bids for mail delivery were made and considered, but there was such poor performance that the contract was up for grabs to whoever could meet the basic requirements.

William Lovette, William Buckley, and Flint Bixby and Company

William Lovette was a Republican state senator representing the Monterey-Santa Cruz area in Sacramento, and he had worked as a special agent investigating matters that came up between Indians and whites in Southern California. In 1864 he campaigned for Lincoln throughout both Northern and Southern California, traveling

Los Angeles to San Francisco.

 STAGES **OF THE**

COAST LINE STAGE COMPANY

DEPART DAILY, VIA

San Buenaventura, Santa Barbara, San Marcos, San Luis Obispo, Passo Robles, Hot Springs, Salinas, Natividad, San Juan, Gilroy; hence direct by Railroad.

Through Tickets issued to San Francisco.

Passengers have the privilege of lying over at any of the above points, and resume their seats at pleasure.

WM. BUCKLEY,
General Superintendent.

A. BRUNSON,

ATTORNEY AT LAW.

Office, Rooms No. 28 and 29, second story, Temple's New Building, **LOS ANGELES, CAL.**

Will practice in the District Court of Los Angeles, and attend to matters in the U. S. Land Office.

H. K. S. O'MELVENY. H. T. HAZARD.

O'Melveny & Hazard,

Attorneys at Law.

OFFICE--Nos. 43, 45, and 46, Temple Block.
LOS ANGELES, CAL.

Special attention given to business in the United States Land Office.

Handbill of the Coast Line Stage Company.

mainly by stagecoach. It may have been this experience that convinced Lovette that he should get into the stagecoaching business. In any case, he used his government connections, and particularly his friendship with the Commissioner of Indian Affairs, to land the mail contract for the California Coast for himself and his associate, William Buckley.

There were many stage lines operating in California during the 1850s and '60s. One of the major operators of the period was the California Stage Company. They operated several lines, the longest one running as far as Portland. Even though stage lines came down as far as Santa Margarita Ranch as early as 1851, roads were not passable further south until 1862. In 1862 Charles McLaughlin and John Butterfield managed the Coast Line (Overland Stage Line) that established Los Angeles as the southern terminal,

This connection, through Butterfield, with the Overland Stage Line resulted in the entrance of William Buckley into the affairs of the Coast Line Stage Company. He served as division superintendent that year and later returned to act as general superintendent during the Coast Line Stage Company's most prosperous days. About 1866, with his new mail contract in hand, William E. Lovette became the proprietor of the Coast Line Stage Company. He recalled Buckley as general superintendent, and the era of the Coast Line Stage Company began.

(There may be some dates in this text that do not correspond with dates about the arrival of the stage in a particular location. In this book we are dealing primarily with the development and operation of the Coast Line Stage Company, and in some areas other stages predated the arrival of that company.)

William Buckley, or "Genial Buck," as he was called by his drivers because of his ruddy face and a jovial disposition, was extremely knowledgeable about stagecoach operations, having worked for Wells Fargo throughout the United States, as a driver, a repairman,

a manager, and a general agent. Lovette set him up as general manager of the Coast Line Stage Company and gave him a free rein in the operation. With his ready laugh and his thorough knowledge of stagecoaching, he was an important asset to William Lovette and the Coast Line Stage Company.

Another asset for Lovette was his connection to Flint Bixby and Company. He was married to Nancy Dinsmore Bixby, sister of Llewellyn Bixby, one of the partners in the Flint Bixby company. This connection helped make possible a loan from Flint Bixby and Company to help ensure adequate financing. Flint Bixby and Company were involved in many enterprises at the time. They were sheep ranchers, land owners, bankers, and developers. (Another brother, Jotham Bixby, was on the boards of several banks and was instrumental in the development of Long Beach, Lakewood, Paramount, and Bellflower; Jotham, along with Flint Bixby and Company, had many large holdings throughout Southern California, including Rancho Los Cerritos, a portion of the Palos Verdes Peninsula, and an investment in the Irvine Ranch.) According to Sarah Bixby, in her book, *Adobe Days*, Flint Bixby and Company were prime movers in the Conejo road to Santa Barbara, and they also helped develop the Cuesta Pass road in San Luis Obispo County and eventually helped organize and bought stock in the Santa Barbara & Santa Ynez Turnpike Company, which built the short cut over San Marcos Pass to Los Olivos. By loaning money to Lovette, the company became financially involved with the Coast Line Stage Company.

With a loan from Flint Bixby and Company, Lovette and the Coast Line Stage Company purchased several brand new red and yellow coaches from the Abbott and Downing wagon factory in Concord, New Hampshire. These were coaches that Wells Fargo had ordered and couldn't take delivery on because the railroads were playing havoc with their stage routes all over the United States. In addition to these fine coaches, the original inventory of the young

company included 270 head of horses; twenty-two stations with buildings, hay, and grain necessary to take care of the stock; twenty-three stages (four of which were mud wagons); and one freight wagon. Each station along the way had many sets of harness for quick changes needed to keep the stages moving. There were furnished offices in San Francisco, San Jose, and San Juan Bautista, and a complete repair facility at Santa Barbara, with blacksmith and harness shops, stocking such supplies as iron, lumber, and tools.

In 1867, Flint Bixby and Company became further involved in stagecoaching when William Lovette was unable to make payments on the loan they had given him. Lovette had run unsuccessfully for governor about this time, and he may have used profits from the Coast Line Stage Company to finance his race. In any case, he left the the company, and Flint Bixby and Company took over the operation. Buckley stayed on as general manager of the company, which now offered service up and down the coast three times a week.

During this period, the Coast Line Stage Company was also known as the San Juan Line, Bixby Overland Stages, and the Bixby Line. There were probably some other names used by disgruntled passengers that we couldn't print. But the most commonly used name was the Coast Line Stage Company.

The route from Los Angeles to San Francisco essentially followed the old mission trail, El Camino Real (see following page). However, as time went on, population shifts improved routes, and new methods of road building brought changes to the route. The Santa Susana Pass was blasted out of solid rock in 1861, but how this affected the Coast Line Stage Company is not entirely clear. The route out of Santa Susana Pass is much easier to travel than crossing the Conejo, and the railroad had a great deal of influence. But there is little written evidence of the exact route of the Coast Line Stage Company. What we do know is that the main highway, today known as Highway 101, was established in 1875. There were major changes in Santa

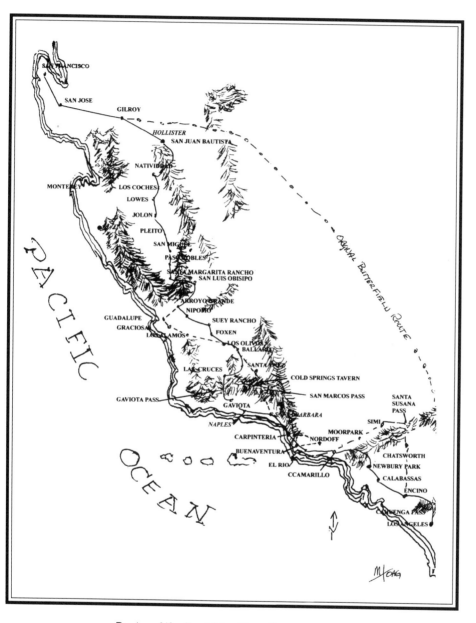

Routes of the Coast Line Stage Company.

_____ Original Coast Line Stage route.

__ __ __ Later route, after population and mail service
had changed.

Barbara County also. In 1875, the route from Foxen Canyon to Ar-royo Grande changed to a road through Los Alamos, La Graciosa, and Guadalupe. Population had shifted to these towns, and the need for mail delivery had increased. This new route was short-lived, how-ever, because of the coming of the Central Coast Railroad in 1876.

Flint Bixby and Company had taken over the operation of the stage line to discover that the route through Gaviota Pass was cum-bersome and ran down two sides of a triangle. They worked with a group of doctors, lawyers, and businessmen from Santa Barbara and Santa Ynez to develop a road over San Marcos Pass, a more direct route. The Santa Barbara and Santa Ynez Turnpike Company, in-corporated in 1868, developed the toll road over the pass and oper-ated it until the County of Santa Barbara purchased the right of way in 1898 and removed the toll.

Stagecoaches

What a sight! Six matched horses trotting along at a smart pace, cre-ating great clouds of dust as the coach goes swaying and jolting along the rough trail.…

The two main types of stages that ran up and down the coast were the Troy and the Concord. The Concord, the more commonly used, was named for the town of its origin, Concord, New Hampshire, the home of the Abbott and Downing wagon factory. The coach weighed about twenty-five hundred pounds and cost about fifteen hundred dollars delivered to the wharf in San Francisco.

The Concord had a hardwood-paneled body that measured 66 inches by 144 inches. It was oval shaped, like the coach used in the Fisher Body logo. The body was framed in ash and oak and paneled with poplar. The paneling was usually painted wine red and lemon yellow, and the running gear were striped with black. The hardware was created of Norwegian iron.

The stage body was equipped with leather-upholstered seats, uncomfortably hard. There was room for six adults on seats facing each other, and there was a jump seat in the center that could accommodate an additional three adults. The body rested on heavy leather straps called thoroughbraces, instead of springs; these more or less absorbed the shocks of the rough roads. This arrangement caused a pitching motion, rather like a teeter-totter, sometimes causing motion sickness. The thoroughbrace system, though, made the pull easier for the horses than metal springs. The driver sat on the right side of the elevated front seat, with his right foot on the brake beam and his left foot on the dashboard.

An iron railing six inches high surrounded the roof of the Concord. This was intended to provide anchorage for the ropes used to tie down the passengers' luggage too large to fit into the leather-curtained "boot" at the rear of the coach. The iron rail also enabled passengers to sit on the coach, dangling their legs over the sides and

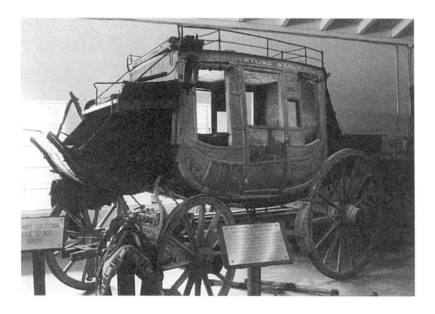

A typical Concord wagon in the Santa Ynez Museum.

holding onto the rail, thus allowing the coach to carry more than the nine or ten passengers it was designed for. There are stories of coaches arriving in San Juan with as many as twenty-nine people aboard.

These Concord coaches, as mentioned above, were the most popular coaches used, and they were the ones used regularly on the route between San Juan and Paso Robles, where the traffic was heaviest and the road had the fewest grades. The other type of coach, the Troy (made in Troy, New York, by Eaton Gilbert and Company), was similar in construction, but it was heavier and did not perform as well.

Another type of coach, the mud wagon, was used in foul weather and on routes where there was a steep grade or tough terrain. The mud wagon had the same basic construction as the Concord, but it was lighter, and the body was more square and was slung lower to

Santa Maria Historical Society

A mud wagon on Rocky Mountain Road en route to San Luis Obispo.

the ground on the thoroughbraces, making it almost impossible to overturn. The mud wagon was not very graceful, but it was the right choice for rough conditions.

Passengers

Anyone who makes claims about how tough it is to travel today should stop and consider what it was like to travel by stagecoach from Los Angeles to San Juan Bautista in the late nineteenth century. The coach was crowded, the seats were hard, the coach jerked and swayed, and there was always the weather to consider—from muddy and cold to hot and dusty. Often the male passengers had to get out and walk alongside the coach up a steep hill; sometimes they even had to push. In the coach, the travelers, both men and women, wore cloaks of linen that tied at the neck and covered them from head to foot to protect them from dust. The dust of the road, the heat of the day, and the closeness of the coach were often nearly smothering.

It is no wonder that the stage stops were so popular, or that most passengers headed straight for the washroom when they stepped down from the stage. Actually, many a male passenger would stop first at the bar to wash the dust from his throat before proceeding to the washroom to take care of the rest of his face. First things first.

Stage Drivers

They had nicknames like "Roan," "Big Sol," "Sage Brush Jack," and "Curly Dan." They were a colorful, entertaining, romantic bunch of characters—part gentleman, part roughneck, and never at a loss for words. If you were lucky enough to ride on top in the driver's box, you would be treated to some yarns as big as all outdoors, about bandits and weather and women. The drivers loved to gab and loved to

TEN COMMANDMENTS FOR STAGE PASSENGERS

1. Abstinance from liquor is preferred. If you must drink, share the bottle. To do otherwise makes you appear selfish. And don't overlook the driver.

2. If ladies are present, gentlemen are urged to forego smoking cigars and pipes, as the odor of the same is repugnant to the weaker sex. Chewing tobacco is permitted if you spit with the wind, not against it.

3. Gentlemen passengers must refrain from the use of rough language in the presence of ladies and children. This does not apply to the driver, whose team may not understand genteel language.

4. Robes are provided for your comfort during cold or wet weather. Hogging robes will not be tolerated. The offender will be obliged to ride outside with the driver.

5. Snoring is disgusting. If you sleep, sleep quietly.

6. Don't use your fellow passenger's shoulder as a pillow. He or she might not understand and friction could result.

7. Firearms may be kept on your person, for use in emergencies. Do not discharge them for pleasure, or shoot at wild animals along the roadside. The noise riles the horses.

8. In the event of a runaway, remain calm. Jumping from the coach may kill you, leave you injured, or at the mercy of the elements, highwaymen and coyotes.

9. Topics of discussion to be avoided have to do with religion, politics, and above all, stagecoach robberies or accidents.

10. Gentlemen guilty of unchivalrous behavior toward lady passengers will be put off the stage. It is a long walk back to Santa Barbara. A word to the wise is sufficient.

swear, but they were always gentlemen to the ladies. In fact, the re-
cords show that their kindness to the ladies was occasionally returned,
causing an unscheduled delay and making the stage arrive late.

One thing was sure: when the driver was in the "box," he was as
much in command as the captain of a ship. No one dared tell him
what pace the horses should take or anything else about driving the
coach. The symbol of his command was his whip, which had a sil-
ver tip and a silver band for each year of service. One veteran Coast
Line Stage driver, Jim Webster, had a whip with fourteen bands.

Before Wells Fargo became owners, stagecoach drivers earned
one percent of the amount of money they were carrying, which was
a fee for delivering letters and doing other errands as well as driv-
ing the coach. If a fare was under one dollar, the driver also got to
keep that. After Wells Fargo took over from Butterfield, the driv-
ers were paid salaries as high as $125 a month. That was a lot of
money for those days, but then we must remember that these driv-
ers worked hard and it was dangerous work at that.

A driver could be expected to drive for twenty-four hours straight,
through every kind of weather imaginable. Stories are told of more
than one driver who got the mail through by unhitching the stron-
gest horse and fording a swollen river astride the horse, slipping and
struggling through raging current with the mail bag slung over his
shoulder. Then there were the "road agents," or bandits, who lurked
on many of the steep grades and passes. The stage owners provided
no firearms for protection and told the drivers to give up the strong-
box if they were robbed, reasoning that if there were shooting, pas-
sengers might get hurt and the liability would be costly.

Maybe the drivers' pay wasn't all that high after all.

One of the best known stage drivers was Charley Parkhurst, who
began his driving career in New England, long before gold fever hit.
The lure of California finally got to him and he came to the Golden
State and settled in the Sacramento area. This colorful driver was

A stage trip over the Santa Ynez Mountains.

described as a lean, lantern-jawed, tobacco-chewing chap in blue jeans. Charley drove for years in the Sacramento area until one day he gave it all up and retired to what is now Moss Landing, in Monterey County. Charlie died there in 1897. After his death it was discovered that Charley was a woman. She had fooled everyone for fifty years.

Another driver who became a legend was W.H. Taylor, also known as "Shotgun Taylor." He had been a Wells Fargo messenger throughout Nevada in the early staging days and was the man most feared by road agents because of the colorful way he used his sawed-off shotgun. Taylor was the Division Superintendent in San Luis Obispo from the inception of the Coast Line Stage Company, and he eventually became a part owner of the company.

The End of an Era

Flint Bixby and Company owned the Coast Line Stage Company until 1878, when they sold it to General Manager William "Genial Buck" Buckley and W. H. "Shotgun" Taylor. Flint Bixby stayed involved in transportation by buying into the Santa Ynez Turnpike Road Company and helping to build the road over the San Marcos Pass in 1868, but their active involvement in the Coast Line Stage Company was over.

By getting out of the stagecoaching business, Flint Bixby demonstrated their talent for staying in step with California history. The Southern Pacific Railroad had arrived in Los Angeles two years before, and stagecoaching was already on the wane, although a number of feeder lines continued to meet trains at various rail heads up into the late 1880s. Smaller railroads were being built as well: the Pacific Coast Railroad extended to Los Alamos, where it met the stage. In 1881 the Pacific Coast Railroad connected San Luis Obispo

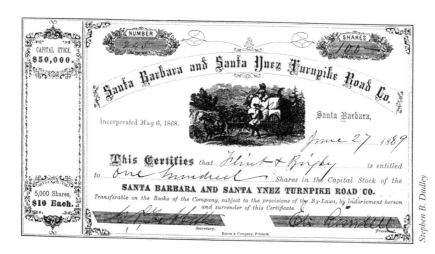

Flint Bixby & Co. invested heavily in the Turnpike Co.
after they sold the Coast Line Stage Co.

to Arroyo Grande, and the following year the service was extended to Santa Maria and Los Alamos and eventually Los Olivos.

Buckley and Taylor owned and managed the business until 1901, when the last stage went over the San Marcos Pass, ending the era of stagecoach travel up and down the California Coast.

⤝Stops Along the Way⤞

Los Angeles

Our journey begins in Los Angeles, the southernmost stop of the Coast Line Stage Company. Los Angeles in the 1860s was a city of about four thousand people living in one-story adobe houses with thick walls and flat roofs covered with tar from the La Brea tar pits. The predominant language spoken in Los Angeles was Spanish.

From 1852 to 1870, the stage stop for Overland Stage, the San Pedro Stage, and the Coast Line Stage Company was the Belle Union Hotel, a one-story adobe on Main Street across from today's Los Angeles City Hall, owned by the mayor of Los Angeles. There was a corral to the rear of the building, stretching to Los Angeles Street. On the north side of the corral, extending from the back door of the main hotel to Los Angeles Street, were the Belle Union's guest rooms. The rooms were six by nine feet, with seven-foot ceilings and dirt floors. They were advertised as "the best rooms south of San Francisco." On the other side of Los Angeles Street, facing the corral, was a two-story building housing the *Los Angeles Star*.

The main building housed a well-stocked and well-patronized bar. Horace Bell, who first arrived in Los Angeles by stage from San Pedro Harbor in 1852 at the age of seventeen, wrote later in his *Reminiscences of a Ranger*, "I most solemnly assert that the patrons who came and went from the Belle Union bar were the most bandit,

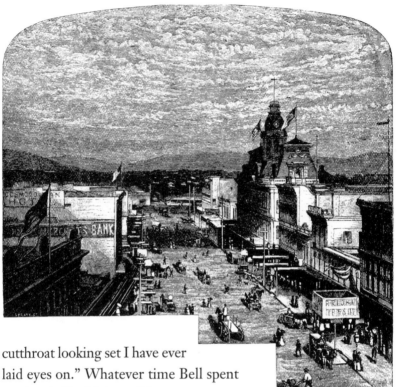

cutthroat looking set I have ever laid eyes on." Whatever time Bell spent in the Belle Union did not seem to do him any harm, however; he went on

Main Street, Los Angeles.

to become a prominent citizen and a major in the Los Angeles Rangers.

Dr. J.B. Winston gained control of the hotel in 1856 and, with the help of several other persons, made significant improvements. They added a second story and fine dining room, which became the only first-class restaurant in Los Angeles. A steam whistle on the roof of the hotel gave a shrill blast to call regulars and transients to meals.

It may have been a first-class restaurant, and the Belle Union may have had the best rooms south of San Francisco, but Los Angeles was still the wild west. In 1865 there was a gunfight out front, killing two persons, injuring several passengers from the unloading

stage, and killing a horse in harness. Los Angeles deserved its nick-name, "Los Diablos."

Nevertheless, Los Angeles was, even then, the destination of many a traveler, and newcomers were quick to appreciate the wonders of Southern California. The following letter, dated Los Angeles, California, November 29, 1866, shows some of the highlights of a stagecoach ride from San Francisco to Los Angeles. As the letter shows, not every traveler chose to stay in the hotel; this party found other accommodations.

My Dear Aunt and Uncle:

We arrived here day before yesterday about noon, after refreshing the inner man, or rather, woman, went to bed and remained there until the next day about the same time. That was staying in bed with a vengeance, I admit, but it was none too much after being jostled and pitched about in the stage at the rate we have been.

Everything is so strange here, you have no idea what a time we have had. At length we came across the Marshal of Los Angeles who rendered us great assistance in getting a place to stay. We have now a good room about fifteen feet square in a brick house with a privilege of cooking anything we wish and all for $2.00 a week, cash down. Carpets are considered quite superfluous in this country and we have only a small piece before the bed, but the furniture is very comfortable and we have a cozy little fireplace. Altogether we are very well off and it is comfortable to feel that we are not going beyond our means. I was very uneasy at the hotel for every mouthful was so expensive and we did not feel at home besides. As we only got here yesterday evening, and it took time to get to write, I have not written a word for the papers yet. I think we have quite a job before us to write $100 worth, don't you?

Santa Barbara Harbor.

We rested two nights on the way, one of them being at Santa Barbara. That is really a much prettier place than this one and vegetation was farther advanced there than here. This puzzles me as Los Angeles is farther south. We have walked through several large orangeries and picked fruit from the trees. January and February are the months for oranges here but the trees are loaded with fruit now. Most of them are green, but there are plenty of ripe ones too. The grapes were all picked and tons of grapes and pears hung up along the rafters of the immense sheds to dry for winter use.

Business is reviving here on account of the mines near by, and a number of large buildings are going up, but, take the city through, it is a funny sight. As you drive through it looks as much like a mass of ruins as anything. The majority of the houses are but one story high and very low at that. Instead of fences they have high walls built of adobe and these are mostly in a dilapidated condition. Inside of these rickety concerns you

will see the most lovely gardens of flowers and fruit. I have seen little trees perfectly loaded with oranges nearby as large as my head, but these nor the California lemons are not very good to eat. In our yard there are several orange and pepper trees and the foliage of the latter is perfectly beautiful. It is like graceful feathers and bears blossoms and fruit in all stages at the same time.

I can give you no idea in a letter of the people here. Most of the American men have Spanish or rather Californian wives and the Spanish language is spoken by everyone. It is singular to see how white men drop into the ways of these people.

Irrigating an orange grove.

It looks very much like rain this afternoon but the air feels nothing like the air in San Francisco. The climate is like summer and I know that I shall get better here. I am not rested from the journey yet, for you must know that at best, it is very tiresome. The agents, drivers, etc. of the stage line showed us every attention along the way. Mr. Lovette, the proprietor of the road, came out to the stage in San Juan and handed us a letter to the employees of the Company to make the trip as pleasant as possible and they certainly did so. Don't you think we have been favored?

The letter (which was later reprinted in *Historical Record and Souvenir,* by the Pioneers Society of Los Angeles County) was unsigned but was believed to be written by Miss Mary E. Hall, because there was an accompanying letter signed W.E. Lovette asking the employees to see that Mrs. Hall and her daughter have as agreeable and pleasant a ride as possible.

Don Pio Pico.

In June of 1870, the stage stop was moved to the Wells Fargo office in the new Pico House hotel on Main Street, across from the plaza and today's Olvera Street, on the site where Jose Antonio Carrillo had built his famous adobe in 1821. The Pico House was built by Pio Pico, California's last governor before statehood, who mortgaged much of his San Fernando Valley holdings to raise the $115,000 needed for construction of the three-story stone and

brick building. An additional $35,000 was spent on the furnishings. There were eighty rooms, and the guests had the luxury of gas lighting.

The ground floor contained the hotel office, a lobby, two dining rooms, and two stores, one of which was the Wells Fargo office. The Coast Line Stage Company most likely shared this space. The second floor was composed of suites and a public parlor. One could reach his box at the Merced Theatre and be seated without going outside and mingling. The third floor contained guest rooms of various sizes, some equipped with baths.

Stagecoach passengers who splurged and stayed at the Pico House long remembered its elegance. It remained the stage station until the railroad arrived in 1876.

Meanwhile, the Belle Union still functioned as a hotel. In fact, that building remained until 1940, when it was torn down. By that time it had become a run-down flophouse. Today only a plaque marks the location of the first stage stop in Los Angeles.

Rancho El Encino

Nine miles out of Los Angeles, near the Cahuenga Pass, there was a rest stop. The next stop after that was Rancho El Encino. When Butterfield established the overland mail route in 1858, following the old El Camino Real, Rancho El Encino became a way station, and it remained a stage stop well into the 1880s. During that time Rancho El Encino was always an important stop for people traveling by stagecoach from Los Angeles to San Francisco, no matter which route they took out of the San Fernando Valley, whether by the Conejo Road to Calabasas or the Santa Susana Pass Road to Chatsworth.

Vincente de la Ossa had purchased this 2400-acre rancho in 1849,

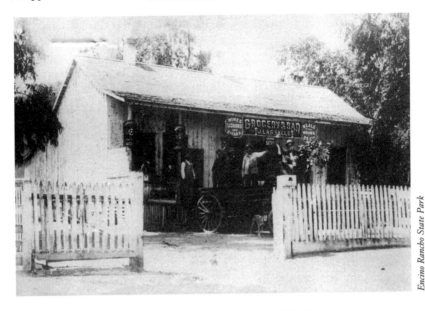

Encino Rancho State Park

Stage stop, bar, and grocery store at Encino.

primarily for the hides and tallow from the cattle ranching. He opened the Rancho to paying visitors in 1860 with the following announcement, which appeared in the *Los Angeles Star* on January 29:

> I have established at my Rancho known by the name of *The Encino*, situated at a distance of 21 miles from the city, on the road to Santa Barbara, a place for affording accommodations to the people traveling on this road. They will find at all times food for themselves, and their horses, beds at night, etc. I hope those wishing to call at our place will not forget to bring with them what is necessary to defray their expenses.

Travelers stayed at the nine-room adobe, which was built next to the largest and finest spring in the San Fernando Valley. Charles Rowe, of the Ventura Historical Society, made the following statement in 1937 concerning Encino and the location of its buildings:

Recollection goes back to October 1886, stages still running. Butterfield started the stages up the coast route...1st (Los Angeles County) 8 Mile House, in Cahuenga Pass...2nd (Los Angeles County) Encino Ranch—stage station about 20 miles from Los Angeles. Stable left side of road going north and ranch building on right side, two story adobe. Old adobe still standing. A French family owned it; lived in adobe. On same side of barn was building, part adobe and part frame, used as saloon and roadhouse. Always had a bar. Fed and roomed guests.

De la Ossa died in 1861. The ranch was eventually sold to J.P. Thompson, who kept it for two years and sold it for a handsome profit to Eugene Garnier in 1869. Garnier was from France, and he used the old-country methods of shepherding. He was reported to have twenty employees and 25,000 head of sheep. He spent a great deal of money improving the property; he erected a fence around the perimeter of the ranch, walled in the spring, and built a two-story house modeled after his birthplace in France. In 1870, when it was rumored that the stage route was going to be changed back over the Conejo Pass, he built a roadhouse across the road from the hacienda complex. In 1874 Major Ben Truman described the Encino Rancho and the roadhouse in his article published in *Semi-Tropical California*:

On the Encino is a remarkably fine spring, which flows a number of thousand gallons of water daily, and is inexhaustible. It is very palatable, and is as soft as water possibly can be. Horses and cattle will come for miles to drink from this spring, which, compared to other water, to the quadruped, is like champagne to cider, with man. This water is piped all over the household premises, at an expense of $1500. In the way of lumber, Mr. Garnier used last year 150,000 feet of fencing alone. One of the attractions of the place is the two-story

boarding and lodging-house for the men, built of stone taken from the ranch, one hundred and forty-eight by forty-two feet; containing large and airy sleeping-rooms, dining-room, kitchen bakery, etc. Already this gentleman has spent $45,000 in improvements; and not content, he is finishing a public house, which will be the most complete roadside inn run in Southern California.

The roadhouse burned twice and was rebuilt both times. The ranch and roadhouse eventually became a clearinghouse for Basque people coming to Southern California and is believed to have been a big cog in the Basque communication network. Today the site of the roadhouse has a bank built on it.

Conejo Stage Road

After leaving the Rancho Encino, the Coast Stage would travel across the San Fernando, following the old El Camino Real, or King's Highway, which was approximately where Ventura Boulevard is now. This route went through ranch after ranch, through very productive country with good soil and good roads. Half-wild cattle roamed the countryside, with no fences to keep them in check, and there were many horses also, about a hundred for every six hundred head of cattle. The next stop was Calabasas.

Calabasas

Calabasas, in the "Canyon de las Calabasas," or canyon of the wild gourds, had been the site of one of more than two hundred Indian rancherias (villages) that dotted the San Fernando Valley. By the time it became a stage stop, it was of course populated by whites, and it was known at that time to be one of the toughest and wildest stops

in California. A dance hall and saloon stood on the south side of the Calabasas jail, where they kept pioneer desperados. Alongside the jail, made of heavy timbers spiked together, was a hanging tree. Another tree beside Kramer's store served the same purpose, but was used by mobs who administered swift and complete punishment for crimes.

Kramer's store was probably the stage stop. Or it may have been the Leonis Adobe. Or it could have been both at different times. Stage stops often changed, so there might have been several over the course of the stagecoach era.

Newbury Park

The stage stop in Newbury Park was the Grand Union Hotel, a well-maintained two-story building fronted by large white oaks, cedars and ivy plantings. It was built in 1876 of redwood from Northern California, in the Monterey style, with two stories and a wrap-around porch and balcony. According to the Ventura newspapers, the Grand Union Hotel had a first-rate table and accommodations and also provided fishing, shooting, and bathing.

The hotel was originally located on the present corner of Ventu Park Road and the Ventura Freeway; it was moved to its present site in recent times when land was taken for the freeway and the building was threatened with being demolished. Over the years the Grand Union has been used in a variety of ways. At one time or another it has been a post office, a boys' military academy, and a restaurant and gift shop. But its early days are recalled by its modern name and location. Now known as the Stagecoach Inn, it stands in a park setting that houses a carriage house and various valuable historical collections.

Camarillo and El Rio

The village of Camarillo (also known as Springville and Springfield) was founded in 1883, where Las Posas and La Colina Ranchos came together at the west end of Pleasant Valley. El Rio (also called Centerville and New Jerusalem) was another community along the way to Ventura; it contained a post office, a church, and a few other buildings.

Santa Susana Pass Road

The other (and earlier) route out of the San Fernando Valley was the Santa Susana Pass Road, which led through Chatsworth and Simi Valley. The stage stop in Chatsworth during the 1860s and early 1870s was the adobe home of Geronimo López, which also served as the first San Fernando Valley post office, beginning in 1869.

When the Simi Valley Pass (the name comes from the Chumash Indian word for little long fleecy white clouds) was cut out of solid rock by General C.D. Beal, a third viable passage was opened out of San Fernando Valley. The pass was also known as "Devil's Slide Link," so named by the stage drivers. The original pass road was extremely steep and rough, with immense gray sandstone boulders everywhere. At the foot of the mountain there were live oaks in thick ranks of unbroken forest. A broad fairly level valley awaited the traveler after the exciting experience of Santa Susana Pass.

Moorpark, a stop for changing horses, was the next stop as the stage traveled along what is now Los Angeles Avenue. Then the road turned west, and the stage eventually arrived at El Rio and carried on to Ventura.

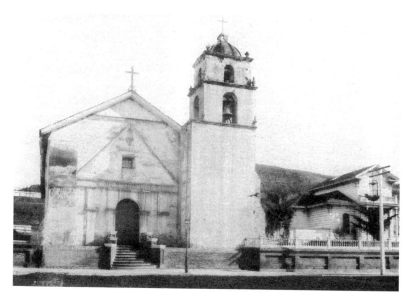

San Buenaventura Mission.

San Buenaventura (Ventura)

The Buenaventura Mission was established on March 31, 1782, approximately one hundred years before the fist stagecoach rattled through the area. It was founded on Easter Sunday in solemn ceremonies conducted by Father Serra and his assistant Father Pedro Cambon. A cross was raised, the High Mass was sung, and a sermon was preached. Over the following years a chapel and gardens and large sanctuary were built.

In the secularization period that followed, however, the stewards of the mission did little to retain its proud heritage, and by the 1860s the garden and most of the facilities were in ruins. The village of Buenaventura, located just south of the Ventura River, had only a few inhabitants. The first stage stop was at the family home of José Arnaz. A later stop was the American Hotel, located on the south side of Main Street, not far from the mission.

Today Ventura is a thriving city, the county seat of Ventura County, and the Buenaventura Mission has been restored.

Rincon (Corner or Nook)

High bluffs and cliffs rise from the shore all along this stretch of seacoast. The beach is strewn with rocks, and the waves break high above the sand onto the cliffs at high tide. The drivers had to wait for the tide to go out and then make a mad dash for Carpinteria. They rode sometimes on sand, close to the water, sometimes over soft sand hills, sometimes over flat rocks with deep gulches, and sometimes—worst of all—over big boulders piled together as only the sea can pile them. Often, because of the length of time it took to travel over this stretch of beach, they would get caught by the incoming tide. Sometimes they lost baggage, and they even

Rocks, impassable cliffs, and high tides
made the trip along Rincon take up to five hours.

occasionally lost the mail; but there are no reports that any lives were lost. Nor was the sea their only hazard, as Rincon proved an effective place for bandits to earn a living, relieving the passengers of their cash and jewelry. Many a time the stage rolled into the next stop, Carpinteria, its side splattered with sand, its wheels draped with seaweed, and the Wells Fargo strong box gone.

Carpinteria (Spanish for "carpentry shop," named for the Chumash canoe building site near the tar pits)

The first Carpinteria stage stop was near the foot of the present Cravens Lane. It was later moved to the east side of the valley at Olmsteads gate and then it was moved to Henry Dally's store at the bend of the road, Rincon Point, close to the beach so that drivers could be prepared to take advantage of the outgoing tides. For a while there was a station in the center of the town of Carpinteria, kept by former stage driver Andrew Lane and station agents Squire Edward Whitney and M.D. Cheney.

The Rincon was abandoned in 1878 as a stage route when Ventura County bonded itself to build a new road through Casitas Pass, bypassing the Rincon altogether. When the stage came over the new Casitas Pass Road, a new stage stop was established at Shephard's Ranch. James Shephard and his wife had no plans to operate an inn; it was to be a simple rest stop for the horses. But Mrs. Shephard began preparing lunches and eventually providing cabins for the passengers. The fame of their delicious pit barbecue and their fine service spread, and people began coming over from Ojai and down from Santa Barbara. Even after the stagecoach days ended, the Shepard Inn was popular among the wealthy people who wintered in Santa Barbara. Many of Santa Barbara's posh hotels, including the Potter, the Arlington, and the Miramar, had carriages that made regular trips to Shepard's. The Shepard Inn's register included the names of many

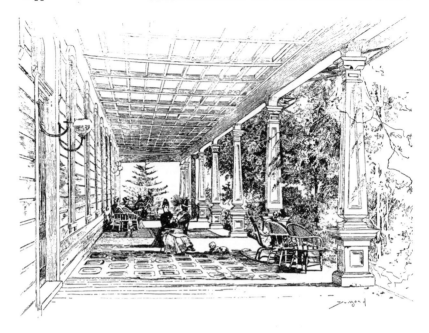

The Arlington Hotel veranda, Santa Barbara.

celebrities and important people, including the Bixbys, presumably out checking on their stage line. The Shepard Ranch was sold in 1927, and the Shepard Inn stagecoach stop is only a memory.

In 1886, when stagecoaching was in full bloom and the Casitas Pass Road was in operation, *Harpers Magazine* ran a story about a young man and his bride who had engaged a stage with four horses to make a trip over the pass to Ojai. Had they continued on to what today is called Ventura Boulevard and turned west, continuing to Mission Buenaventura, they would have completed this loop of the Coast Line Stage Company's route. Their account of the trip shows the beauty of the countryside.

Early in the season as it was, the day when they started was June-like in its bright freshness—clear, mild, and beautiful. For the first two hours the way led down the coast through

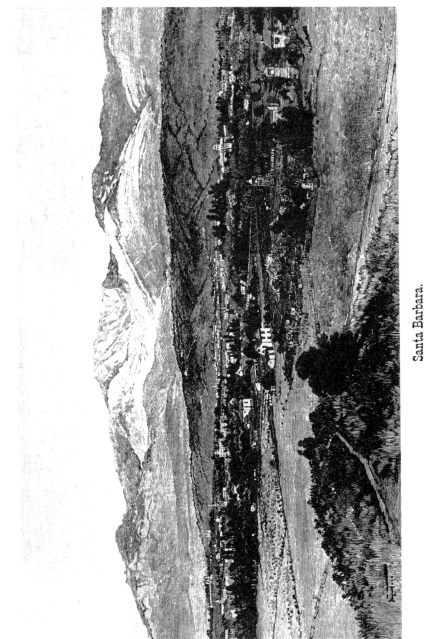

Santa Barbara.

El Montecito and Carpinteria. The fields of green grain and blue-flax, live oaks and wild flowers, the orange groves and nut orchards, gave, with the sea and sky, a coloring rich and varied. In Carpinteria the road ran near the beach, past a line of sand-dunes, now overgrown with trailing vines and flowers thrown into bold relief against the background of the ocean. To the left, reaching the mountains, were open fields, some frilled with walnut orchards and fruit trees, others freshly ploughed and ready for their crop of Lima beans, of which the Carpinteria Valley is the home. At the mouth of the pass the road turned abruptly northward and entered a narrow, winding cañon, guarded by steep hill-sides overgrown with oaks and tangled brushwood. Down the centre of the ravine flowed a noisy creek; and on both banks was a network of ferns and morning-glory vines. Before reaching the steepest part of the pass an hour's rest was taken in a spot shaded by large oaks, a short distance from which ran the brook. In every direction there was nothing but verdure—the green of the ferns intensified by the oaks, and that of the trees by the shrubs on the mountain slopes.

As the top of the pass was neared oaks disappeared, and in their place were wild wastes of sage and chaparral, and patches of wild flowers of a hundred different shades—blue, gold, and red. Some of the distant hills appeared on fire, so thickly were they carpeted with the flowers, and so brilliant was their hue. They counted over seventy different varieties without leaving the wagon. When the crest of the range was reached the driver halted, and the little party gazed upon the mountains whose broken contour extended as far as the eye could see. Northward, guided by tree-grown hills, and resting in the very lap of rugged mountains, lay Ojai, a filmy haze softening its outlines, and groves of live-oak. But most admired was the pass itself,

winding in narrow coils around the many hills, and the view
beyond it of the Santa Barbara Valley, blue, softly outlined and
girded by the yellow beach, upon which the waves could be
plainly seen breaking in masses of foam. With a glass the
houses were visible, and with the naked eye all could see a
steamer ploughing its way across the bay to the wharf. Few,
perhaps no other passes in California, have the varied beauty
of the Casitas; none, certainly, has its views of mountain,
valley, and ocean combined in one harmonious whole.

Santa Barbara

The trip to Santa Barbara from Carpinteria went through what is
now Summerland, over Ortega Hill into Montecito, past the slough
(today's bird refuge), along the path of today's old stage highway, and
then proceeded to State Street and turned north. There were many

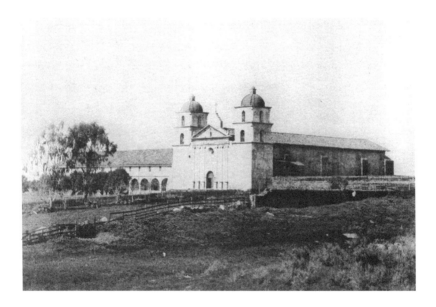

Mission Santa Barbara—the Queen of the Missions.

different stops along State Street, including the post office between
Ortega and Cota Streets, and the many luxurious hotels, such as the
Arlington and the San Carlos.

When the stage left Santa Barbara it went out Hollister Road
(then called Stage Road) and continued north through Cathedral
Oaks and Goleta and on into north Santa Barbara County, a trip that
involved rugged mountains and was made possible by the road com-
pleted in 1861 thanks to the cooperation of Los Angeles and Santa
Barbara Counties.

Dos Pueblos Canyon

This relay station, seventeen miles north of Santa Barbara, was the
first stop for changing horses on the trip north. Dos Pueblos was a
Rancho owned by Nicholas A. Den, a native of Waterford, Ireland,
who arrived in Santa Barbara in 1862, married one of the lovely local
señoritas, bought Dos Pueblos, and raised ten children.

Shortly thereafter, Dos Pueblos Canyon became the site of the
model city of Naples, which was to have been one of the premier at-
tractions on the California coast. On June 1, 1887, John H. Williams
and his wife purchased nine hundred acres on the east side of Dos
Pueblos Creek for fifty thousand dollars. The railroad was scheduled
to pass their lots as it proceeded up the coast. Williams, backed by
a syndicate of wealthy speculators, made plans to build a hotel rival-
ing the Arlington in Santa Barbara and the Coronado in San Diego.
The city was plotted and formed a grid of 250 numbered city blocks.
The city established a dance hall, a hotel, a Wells Fargo office, a U.S.
post office, and some homes and barns. A nationwide campaign was
launched, and hundreds of lots were sold to speculators around the
world who never came near their land.

In time the railroad did reach Santa Barbara, but it was not con-
nected to Templeton until 1901. Meanwhile, the boom collapsed.

When the Coast Line Stage Company changed its route and went over the San Marcos Pass, its stages stopped rolling down Goleta Valley, although stages to Gaviota and Lompoc still continued. The town of Naples remained until 1918, when oilman Herbert G. Wylie purchased the property and had it razed. All that's left of Naples is a ghost town, although there are still problems with the titles to some of the lots sold during the boom.

The crossing at Dos Pueblos Creek was the scene of one of the few fatal accidents for the Coast Line Stage Company. It was winter, and the stage passed through the Naples lane of white picket fences toward the swollen Dos Pueblos Creek. At flood stage the water was wildly raging toward the sea, but the path across seemed to be passable. What the driver didn't know was that the swift-moving creek had undercut the bank and created a drop into the raging torrent. He hesitated and finally decided to cross. The lead horses were caught in the current and the harness was snagged, carrying the horses downstream. The lead horses drowned, but the driver immediately cut them loose and brought the remainder of the team safely to shore. During the melee, a Chinese passenger was swept away, possibly out to sea. His body was never recovered. The other passengers were badly shaken, but they survived.

Gaviota Pass

This broad gap, which sweeps through the Santa Ynez Mountains along what is now Highway 101, was first sighted by Juan Cabrillo in 1542. He anchored two ships, the *Victoria* and *San Salvador*, just off the mouth of the pass, at what is now Gaviota Beach. The crews took on wood and water for the trip around Point Conception in the teeth of a gale.

The Gaviota Pass waited another 225 years before the first white man threaded his way through the sheer cliffs up the coast. Gaspar

The Book Loft, Solvang, California

Gaviota Pass, before the bridge was built, with the road in the creek.

de Portolá camped at Gaviota in 1769 before venturing up the canyon. His men shot a seagull, and "Gaviota," the Spanish word for "seagull," has stuck to the place ever since.

Over the next hundred years, the Gaviota Pass repeatedly played an important role in California history. When the Santa Ynez Mission was established in 1804, Gaviota Pass began to be used regularly for travel by horseback. In 1818, the pirate Hippolyte de Bouchard, who had been successfully pillaging the California coast, was foiled by a troop of soldiers who had gone up the San Marcos Pass and then come back down to the sea by way of the Gaviota Pass to get behind the pirate.

In 1846, Colonel Frémont used a variation of this maneuver against the Mexican garrison at Santa Barbara. Frémont was marching with five hundred men to join forces with Commodore Stockton in Los Angeles to crush the remaining Mexican troops in the

field. Expecting Frémont to go through Gaviota Pass, the Californians set up a trap to annihilate the Americans with tons of rock, which the ambushers planned to blast loose. However, Frémont learned of this trap from Don William Domingo Foxen, at whose ranch he and his men were camped, north of the pass. Foxen and his son led the five hundred men with their mules and cannons over the San Marcos Pass instead on Christmas Eve. Frémont marched into Santa Barbara and captured it without a shot being fired. On January 13, 1846, Andres Pico surrendered, ending centuries of Spanish and Mexican rule in California.

Stagecoaches began rattling through the pass in 1862 when the major boulder blocking the pass was removed. Two bridges were built to make the road passable for freight wagons and other stages. When the Coast Line Stage Company began regular service in 1866, getting through the pass was not always easy. Horses were frightened by the bridges and sometimes passengers would have to walk part way because of the grade and the rock-strewn terrain. Walking gave the passenger a better appreciation of the grandeur of the pass, especially in the spring, when an abundance of wildflowers decorated the sandstone, but passengers grumbled anyway. And in the winter, the pass often became impassable. The creeks became torrents of water, washing out bridges and causing slides. At times like these the mail had to be sent by steamer or carried by hand through the pass to a waiting coach on the other side.

Gaviota was considered a major stage stop between 1862 and 1868, when the San Marcos cutoff was completed. The stage stop, at the mouth of the canyon, was the Gaviota Inn and general store, run by M.F. Burke. Burke was also the manager of the wharf and the telegraph office, and was appointed County Supervisor in 1882. He also owned a small stage line that ran from Las Cruces to Santa Barbara.

Although the stage stop lost its importance when the San Marcos cutoff was completed, Gaviota remained important geographically.

In 1875, a pier was built by W.W. Hollister, Albert Dibblee, and Thomas A. Dibblee, so that ships could load farm produce and other products from the interior that were brought over the pass in freight wagons. The pier served passenger steamers also. This pier was a successful operation until the completion of the Pacific Coast Railroad in 1882 to Los Alamos, after which the pier fell into disuse. As for the Gaviota Inn, it was torn down when a highway was constructed, and all that remains of it is a mound of dirt.

The road through Gaviota Pass remained narrow and winding until 1936, when a modern highway was blasted out of the sandstone. The highway was widened in the 1950s and a tunnel was cut through the rock, preserving the historic value and grandeur of the pass.

Las Cruces (The Crosses)

The name Las Cruces is thought to have been given to the area by the friars when they found two unmarked graves and put crosses on them. It is also possible that the "crosses" refer to several places where smaller streams join the Gaviota Creek on its way to the ocean. In any case, the land of the Las Cruces Rancho was originally part of the Santa Ynez Mission and was granted in 1837 to Miguel Cordero, a soldier from the Santa Barbara Presidio whose father had been in one of Portolá's expeditions. Cordero died in 1851 with no will, and the property was in legal turmoil for many years. The final survey and patent or grant deed was issued to the family in 1883. (When California joined the United States the title of many ranchos was in dispute. Over a number of years, after much testimony and haggling, the Federal Government issued title or ownership with patents.) However the financial need of the family required that the ranch be sold, and Rancho Las Cruces became part of the Hollister-Dibblee Rancho.

In 1833 Miguel Cordero built an adobe on the rancho, and that

adobe still stands. The Las Cruces Adobe has been many things in its colorful career: a stage stop, hotel, saloon, cafe, stable, and blacksmith shop. It may even have been a house of ill repute during a time when Las Cruces was considered a wild town of wine, women, song, and gambling. Other tenants of the adobe raised sheep, cattle, and hay. When Rancho Las Cruces was part of the Hollister-Dibblee Ranch the adobe was used as a supply house.

The adobe was built on a foundation of two or three rows of field stones and mortar. The walls of adobe brick were bound with straw and mortar, then covered with a whitewash of four parts water to one part sand and lime. Doors and windows were put in place as the walls were built, so the adobe bricks could adhere to the wood when they dried. The exterior walls were two bricks wide and the interior walls were one brick wide.

The adobe was modified in 1860 to prepare for the stage franchise. A second partition was placed in the house, creating a bar. A fireplace was also added and the interior was wallpapered. Wooden exterior rooms were completed, as were corrals and a barn.

The local stagecoach station manager in 1866 was Alfred Bascon Williams, who was also the constable, justice of the peace, and deputy sheriff. The station was later managed by R.J. Broughton, who was appointed postmaster in 1869 and again in 1876.

A town developed over the years, with a store, several ranch services, homes, and a hotel. Most of the development was destroyed and covered over when the state developed the highway system through Gaviota Pass.

After leaving Las Cruces, the stage road turned inland at the Nojoqui ranch, a 13,000 acre spread owned by Romundo Carrillo. Here they changed horses after the heavy pull over the Las Cruces grade. The stage then continued on to Santa Ynez and Ballard.

The San Marcos Shortcut

A traveler in stagecoach days needed patience and a solid foundation to withstand the bumps and the long hours of sitting. The trip we have discussed so far has taken a good deal of time: eight to ten hours from Los Angeles to Ventura; possibly ten hours from Ventura to Santa Barbara by way of the Rincon; and another twelve hours to Ballard by way of the Gaviota Pass.

County of Santa Barbara Roads Department

Slippery Rock.

In 1868, a group of people led by Santa Barbara physician Dr. Samuel B. Brinkerhoff formed a corporation to build a toll road over San Marcos Pass into Santa Ynez Valley, ending in Los Olivos. This route would save many miles and many hours to the Los Olivos rail head, and a toll road would pay for itself in a short period of time. Dr. Brinkerhoff's associates in this enterprise were Thomas Bell, owner of the Los Alamos Ranch; three other medical doctors; attorneys Charles Enoch Huse and Charles Fernald; Llewellyn Bixby, owner of the Coast Line Stage Company; and Ed Rinell, manager

of the Santa Barbara Division for Wells Fargo. The toll road was completed that year.

Leaving Santa Barbara on the San Marcos shortcut, the stage headed west along the foot of the mountains on what is now Foothill Road, past Cathedral Oaks (which is no longer there; only the name remains), past Indian Orchard, where the first oranges were grown in California, from trees brought around the horn by ships. The stage then turned north and started the steep climb up the mountain. At some points the grade was so steep that the Chinese coolies who had constructed the road had chiseled out places in the rock so the horses could get a firm footing on the ascent. This part of the trip became known as "Slippery Rock" or "Slippery Sal" to the stage drivers.

At the summit the stage stopped for a noon meal at Kinevan's Summit House, which presented a bill of fare that would do any

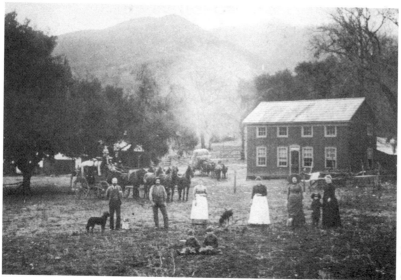

Santa Maria Historical Society

Kinevan's house, at the top of the Santa Barbara & Santa Ynez turnpike road. Mrs. Kinevan was known to serve a mighty good lunch at the noon stopover.

well-to-do farmhouse proud: young chickens, fresh eggs, sweet milk, tender vegetables, and fruits and berries in season. The Summit House was built by Patrick Kinevan, the station agent and keeper of the toll gate, which was located at the San Jose Bridge in front of the stage stop.

After a change of horses and a good meal for the passengers, the stage began its descent into Santa Ynez Valley.

Cold Spring Tavern

The next stop was Cold Spring Tavern, where the travelers could play pool or relax with a cocktail, a bottle of beer, or a hobo soda (a glass of spring water) before continuing on down the hill. Beside the tavern was a bunk house for the stage drivers, and across the street was the road gang house, erected in 1868 to house the Chinese crew that built the San Marcos shortcut. There was also a bottling plant where they bottled "the purest water in the county."

Cold Spring Tavern is still in business; it is surrounded by forty acres and eleven buildings, including the Ojai Jail, which was built in 1873 and brought over the mountain pass to its final resting place.

The floor of the Santa Ynez Valley is comparatively flat. Much of the original road is now under the water of man-made Lake Cachuma, including the stops at San Marcos Station, Chalk Rock Station, and Red Gate Station. The original road is regained just south and east of Santa Ynez.

Santa Ynez (St. Agnes)

This small city, founded one year after Ballard in 1861, was a rural community with saloons, barber shops, and the College Hotel, which was at one time the poshest hotel in the valley. The town boomed briefly with the false hope that the Southern Pacific

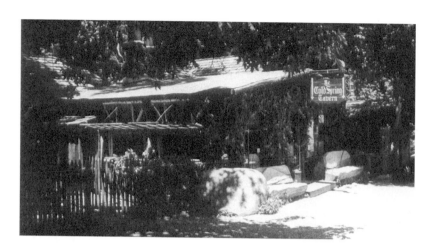

ABOVE: Cold Spring Tavern was established when the turnpike was built.
Dormitories for the Chinese workers are still standing near the tavern.

BELOW: Much of the road from Cold Spring
Tavern to Santa Ynez is under Lake Cachuma.

Railroad would be routed through the Santa Ynez Valley, but that never happened.

Santa Ynez was not on the main stage route until the San Marcos cutoff was established; a stage probably did stop at Mission Santa Ines on its way to Ballard, but it did not come to the town of Santa Ynez until 1868. From then on, the stagecoach stopped twice a day at the general store to deliver mail, change horses, and give travelers a rest.

Downtown Santa Ynez.

Ballard

The first stagecoach of the Coast Line Stage Company to stop in Ballard came in 1862, having come over the Gaviota Pass. Soon it became a regular stop, serving the need for a stopover at the half-way point between Santa Barbara and San Luis Obispo. A group of buildings called the Ballard Adobes was built in 1860, where weary travelers could refresh themselves and have meals. There was a

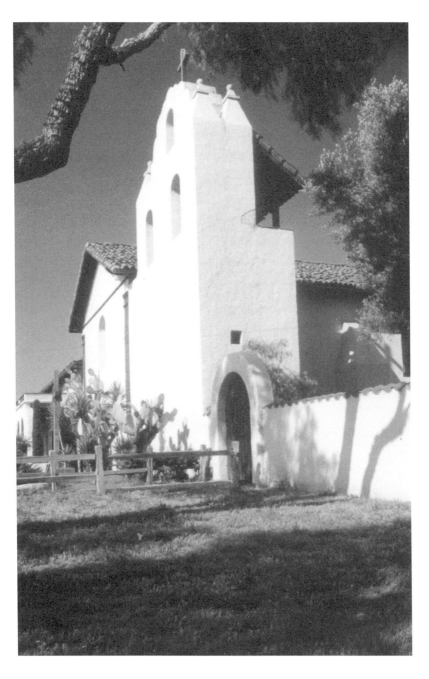

Mission Santa Ines, a stage stop along El Camino Real on the way to Ballard.

dining room for passengers and a small, compact room with no outside entrances that was used as the Wells Fargo office.

In 1866 Mr. Ballard became ill and turned over the reins of the Ballard station to Charles La Salle. La Salle was in charge from 1866 to 1869, during which tenure he built what is known today as "the upper house" and put a wooden floor in the lower adobe.

The city of Ballard, laid out in 1861 by George W. Lewis, grew to be bigger than Los Olivos. But this changed when the Pacific Coast Railroad was extended to Los Olivos in 1886 and Los Olivos won the size battle. By this time, of course, Ballard was largely by-passed by the San Marcos Shortcut.

Now there isn't much remaining in this area, which was once the center of much wheat-growing activity. Only a schoolhouse, a Presbyterian church, a few farms, and the Ballard Adobes are left in place to remind us of the bygone stagecoach days.

The Ballard Station, two adjoining adobes, is today a private residence.

Los Olivos

This subdivision, planned by the Pacific Coast Railroad, became the terminus of their rail line. It was smaller than Ballard when it was founded, but because of the rails and the opening of Mattei's Tavern in 1886 it grew quickly. The tavern, across the street from the rail station, was where rail passengers traded places with stagecoach passengers. From 1887 to 1904 the Coast Line Stage Company had offices in Mattei's and ran at least two coaches between Los Olivos and Santa Barbara every day.

Phillips's history of Santa Barbara County relates an interview in 1927 with John Waugh, a stagecoach driver stationed in Los Olivos, in which he recalled being an old-time driver.

After several years' experience driving in the north, Mr. Waugh was shifted to Santa Barbara and drove out of Los Olivos (his home) north and south. "It was my duty to take the stage when the driver got in from the north in the morning. As soon as the hostler put in a new six-horse team, I climbed up and started.

"The down stage was supposed to reach Los Olivos at nine in the morning but it was often delayed for hours, sometimes days. I had to be ready to start on the minute, because it carried the United States mail, and we had to get that through without delay. So day or night we went as soon as the change of horses was made.

"The stages were large and quite high. They had a row of seats all around the top outside. There was room for about 16 people all told, inside and outside. If the stage was running by night the two lanterns in front up over the wheelers would be lighted and they would throw a little beam ahead, though not much of one. You had to leave a good deal of it to the horses,

and the road was rough. If there was rain, so much the worse.

"At the foot of the mountains there was a change of horses, and at the top of San Marcos Pass there was another. This latter station was kept for a long time by Pat Kinevan. Our next stop was Santa Barbara and the headquarters was the Morris House on Lower State, now [in 1927] called the Central Hotel. We kept the horses in a stable catercornered across the street.

"The run from Mattei's to Santa Barbara took about 6 hours. On the down trip I usually reached Santa Barbara at 3 or 4 o'clock in the afternoon, going back the 62 miles the next morning. The next division north was at Pleito, near the border of San Luis Obispo County. This was shorter than from Mattei's to Santa Barbara.

"South of Santa Barbara the next station was at Old Town, Carpinteria. From there south the route sometimes was by way of Casitas Pass. At other times it stuck to the shoreline, and the drivers had to take a chance of the tide catching them as they were rounding Rincon Point."

During John Waugh's time no guards were carried and the drivers were instructed never to fight. The company reasoned that if a man had a gun and reached for it, the highwayman would undoubtedly shoot him. Then the horses would thunder away out of control, to overturn the stage and kill and injure passengers. The resulting loss from damage suits would be greater than if the driver surrendered the valuables.

Valuables were carried in the Wells Fargo safe in the leather boot in front by the driver's feet. The robber's first command was "Put 'em up!" The second was "Throw off the box."

In earlier days highwaymen usually traveled alone. They

chose steep and secluded grades for their holdup operations, since the stage team could not make good time while pulling hard.

Presently Wells Fargo & Company adopted the plan of fastening the safe to an iron ring built into the stage. A massive chain connected safe and ring, and the lock which held them could be unfastened only by a key at the end of the route. The driver was purposely without a key.

This forced the highway men to double up. While one stood guard with his rifle over the passengers, the other with a sledge either battered the lock to pieces or broke open and robbed the safe then and there.

John Waugh was never robbed. The worst of the bandits had been hanged or shot by the late '70s, though there were still some road agents operating. "I never admitted it at the time," he said with a smile, "but I did have a stand-in with one of the boldest and most successful of the robbers. He was a school teacher in Mendocino and Ukiah when I was a boy. He never stopped me and I never told on him. He would get on and ride with me until he came to the timbered country this side of San Luis Obispo. Then he would bid me goodbye, drop off, and lie in hiding till the next stage came along when he would stick it up.

"He was captured after awhile and sentenced to 3 years in San Quentin. When he came out, Wells Fargo bought him off. They gave him a pass and a pension. He used to enjoy riding over the company's lines with drivers, and he stuck to his bargain and held up no more stages."

At some of the stations near town there was a chance for the passengers to eat. Out in the wilds there was a stove or fireplace at the station, over which the passengers might prepare their own food. The stations were always located near

wood and water. The fare between Los Olivos and Santa Barbara was $5.50 each way, about 9 cents a mile. Meals were extra. Drivers got $125 per month, which was practically clear, as the hotel men were glad to keep them between trips.

Mattei's Tavern

Felix Mattei, born in Cevio, Switzerland, in 1853, came to the United States at the age of fifteen and found his way to San Francisco. From there he worked his way south and managed a saloon in Los Alamos and another in Cayucos, possibly both at the same time. Along the way, he married Lucy Fisher and the couple had three sons.

In 1886 the Mattei family arrived in Los Olivos, a community of cattle ranchers, Indian converts, and the folks who operated the stage stop at Ballard. The Matteis lived in a shack that just happened to be right by what was to become the terminus of the Pacific Coast Railroad line from San Luis Obispo. Mattei realized that this would be a vital link for the transportation of both passengers and produce. He set up shop, serving food to the railroad construction crews. He also built a two-story, seven-room hotel, which he called the Central Hotel. In time it became known as Mattei's Tavern, and after a competing hotel burned to the ground, Mattei's had a virtual monopoly when it came to hospitality in the Santa Ynez Valley.

The second floor of the hotel had a long hall with guest rooms on either side. Each room was furnished with a coal oil lamp, a wash basin and pitcher, a simple bureau and a bed. The grounds were resplendent with lush gardens and romantic paths. Thanks to these gracious accommodations and Lucy's good cooking, the hotel prospered through the years. By the 1890s, its fame had even spread to the East Coast, and no self-respecting millionaire wintering in Santa

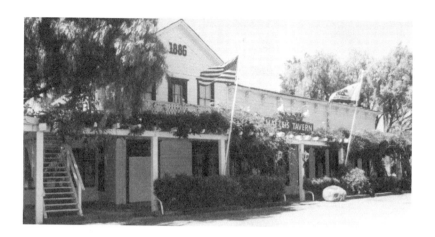

ABOVE: Mattei's Tavern, established in 1886, was the terminal for the Coast Line
Stage Company and stood across the street from the Central Railway terminal.
Passengers were well fed and accommodated in their travels.
Today you can still get an excellent dinner at Mattei's Tavern.

BELOW: Stage office at the east end of Mattei's Tavern.

Barbara would miss a trip to Mattei's Tavern. They'd come over the San Marcos Pass by stagecoach so they could hunt quail, bobtail pigeons, ducks, geese, and deer. The hotel register at Mattei's contains many important names, such as Armour, Pillsbury, and Vanderbilt. Susan B. Anthony also made the trip over the pass, and legend says she had sharp words for the driver, accusing him of an improper attitude toward women, but that may be apocryphal.

Even after the Southern Pacific completed the rail line to Santa Barbara around Point Conception, Mattei's Tavern continued to flourish, and the town of Los Olivos continued to prosper from the large volume of agriculture that was shipped from the rail station across the street from Mattei's. In fact, Los Olivos replaced the Gaviota wharf as the main shipping point for the area.

The east end of the railroad station had a loading dock, a ticket window, a waiting room and living quarters. The railway facilities also included a two-stall engine house, stock pens, a lumberyard, a Fairbanks scale, a red water tower twenty feet in diameter, a windmill, a back-powered turntable, and two outhouses. When the turntable became inoperative, a wye was installed. A donkey engine was used to serve bulk oil tanks south of the engine shed. Kids loved the railroad station; they were sometimes allowed to fill the engine with water and they were allowed to swim in the water tower tank. The train would leave San Luis Obispo at 7:40 a.m. and arrive in Los Olivos at 1:40 p.m.; the return trip would arrive back in San Luis Obispo at 8:45 p.m.

Foxen Canyon Road

The Foxen Canyon Road heads north out of Los Olivos through wild, diverse, and beautiful hills of stately oak and abundant wildlife. The main stop for changing horses in the canyon was the Foxen

Rancho, or "Tinaquaic Rancho," fifty miles north of Santa Barbara and near Los Alamos.

The Tinaquaic Rancho was granted to William Benjamin Foxen, an Englishman, in 1837. Foxen had been a sailor as a young man and had worked his way up to First Officer before he came to California in 1818. He then traveled up and down the coast and eventually dropped anchor in Santa Barbara in 1827. Tired of traveling, he decided not to return to England and began working for Captain Noriega, building schooners in Goleta Bay. He married Eduarda Del Carmen Ozuna in 1831, embraced the Catholic faith, and became known as Don Julian Foxen. Foxen's main claim to fame in California history was his venture over San Marcos Pass with Frémont on Christmas Eve, 1846. Without Foxen's help, Frémont might never have reached Los Angeles or changed the course of California history at the Battle of Cahuenga Pass. Foxen's collaboration with Frémont did not endear him to the local Californians, who made a lot of trouble for him thereafter.

Foxen was a great fan of stagecoaching. Not only was his adobe a main stop, he had the honor of driving the first stage over the San Marcos Pass. He was also the postmaster at the Foxen Rancho station, which meant he had to distribute the mail brought to him in a sack by the stage from the north. While he worked at this, for about twenty minutes, the stage driver permitted his six horses to tear around a two-hundred-yard circle in front of the house, because it was practically impossible to stop the horses on level land between stations. When the mail was sorted, tied, and sacked, Don Julian would hurl the bag into the flying coach and the team would then straighten out and gallop away to the south.

Foxen died on February 19, 1874, as a result of a bite from a black widow spider, leaving a wife and eleven children. After resting in a temporary grave at the ranch adobe, his remains were buried on the

Foxen Vineyards, Foxen Canyon Road

ABOVE: This drawing of Tinaquaic Rancho hangs at Foxen Vineyards, formerly Wickenden's home three miles north of the Foxen rancho.

BELOW: All that is left today of the Foxen rancho are some mounds of adobe and a brass plaque.

A glorious sky, purple mountains, lush rolling hills, and majestic oaks provided spectacular scenery to stage riders along Foxen Canyon Road.

grounds of the chapel of San Ramon, which was built in 1875 by his son-in-law, Frederick Wickenden, and his daughter, Ramona Foxen Wickenden.

After Foxen's death, the stage stop was moved to the Wickenden's home three miles north of the Foxen adobe. The Wickenden house had been constructed of adobe in 1860 and later incorporated into a wooden house built in 1875. There was also a general store and post office. Wickenden raised stock and was also the postmaster of Santa Maria for one year, 1870-1871.

Traveling north on the Foxen Canyon Road, the stage would pass the Juan Adobe, built in 1865. It was a bar and saloon during stage-coach days, and we can suppose that it was a popular watering hole among the bandits who worked the Foxen Canyon Road. Next on the route was the little town of Sisquoc, after which the stage turned right at what is now called Philbreck Road and traveled along the river.

When the stage reached what is now Main Street, it turned left and headed west. Several miles later the stage came to Suey Road and headed north and crossed what today we call the Santa Maria River. A few miles after crossing the river the stage reached Suey Ranch, where the horses were changed.

Los Alamos

The stage route did not go through Foxen Canyon after 1880 but was extended west to create a new stop at Los Alamos. Buildings for lodging and a stage station were erected, along with an eating house for passengers. The yellow two-story house that stands just north of the old Pacific Coast Railroad station was probably one of those buildings. Today this is a private residence. Another stage stop in Los Alamos was the Union Hotel, built in 1880 by J.D. Snider, a builder

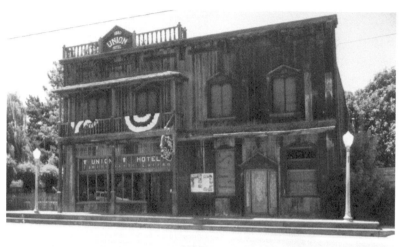

The Union Hotel in Los Alamos, still open for limited stays and meals.

and agent for Wells Fargo. The hotel was burned down in 1886 and then restored in 1915 on the same site. The structure, an authentic adobe, has been many things: the Hotel Los Alamos, a pool hall, a dance hall, and a rooming house for railroad workers. It was even boarded up for eighteen years. R.W. Landing, the present owner, reconstructed the facade to match the original and restored the building's original function, as a hostelry, once again known as the Union Hotel. It is open only on weekends.

During stagecoach days, Los Alamos was an important stop whether you were traveling north or south. There was a direct line from Los Alamos to Guadalupe in the north and to Los Olivos in the South. Eventually, in 1882, this community became the terminus of the Pacific Coast Railroad. The railroad was built primarily to provide transportation for farm produce to the seaport at Avila, but it became a passenger service as well. This service made train travel possible from Los Alamos to Templeton, where passengers

could catch the Southern Pacific north. When the Pacific Coast Railroad was extended to Los Olivos in 1887, stage service to Los Alamos was ended.

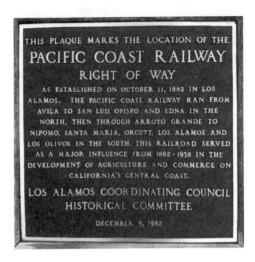

THIS PLAQUE MARKS THE LOCATION OF THE
PACIFIC COAST RAILWAY
RIGHT OF WAY
AS ESTABLISHED ON OCTOBER 11, 1882 IN LOS ALAMOS. THE PACIFIC COAST RAILWAY RAN FROM AVILA TO SAN LUIS OBISPO AND EDNA IN THE NORTH, THEN THROUGH ARROYO GRANDE TO NIPOMO, SANTA MARIA, ORCUTT, LOS ALAMOS AND LOS OLIVOS IN THE SOUTH. THIS RAILROAD SERVED AS A MAJOR INFLUENCE FROM 1882-1938 IN THE DEVELOPMENT OF AGRICULTURE AND COMMERCE ON CALIFORNIA'S CENTRAL COAST.
LOS ALAMOS COORDINATING COUNCIL HISTORICAL COMMITTEE
DECEMBER 5, 1982

La Graciosa

La Graciosa, or "The Graceful One," was a stage stop in northern Santa Barbara County, located between Los Alamos and Guadalupe, near where the Orcutt Expressway is, just south of the Union Oil tanks. Not much is known about this town, although there are some dusty records and some memories have been passed down. A man named Patrick O'Neill developed a saloon and a store near a spring and some willows, according to O'Neill's nephew, Chet Norris.

The town of La Graciosa was established around 1868, and in 1870 the Town Company surveyed for forty lots, expecting to make La Graciosa a full-fledged town. This never happened, however, because railroad and cattle baron Henry Mayo Newhall received title to the Todos Santos Rancho, which included La Graciosa. According to the Guadalupe Telegraph, Newhall ordered the inhabitants to leave La Graciosa and brought a $40,000 suit against them. Allegedly three of the buildings were moved to Orcutt, but no one

knows where. The rest of La Graciosa was burned to the ground, leaving only the name, which was used for a workman camp, a railroad siding, and a ridge for oil drilling activity.

Guadalupe

Rancho Guadalupe was a 30,408-acre land grant made by the Mexican Government in 1840 to Diego Olivera and Teodoro Arellanes. The owners built a house called the Old Adobe directly behind the present location of the American Legion Hall. A general store was built near the Old Adobe in 1845, and the town grew from there. The Old Adobe was the stage stop in Guadalupe as long as the town remained on the main line of the Coast Line Stage Company.

That came to an end in 1882, when the Pacific Coast Railroad completed the line to Los Alamos. The Pacific Coast Railroad began service about 1880 in order to get farm produce to market faster. The only shipping places prior to that time were on the coast, and

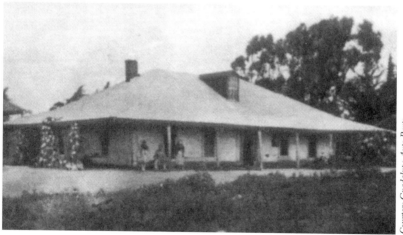

Courtesy Guadalupe Auto Parts

The Arrellanes Adobe was the stage stop while
the stage came through Guadalupe.

getting produce there was difficult. The railroad made marketing farm produce a viable opportunity nationwide. The Pacific Coast Railroad began service in San Luis Obispo and serviced the coastal cities as they developed: Guadalupe, Avila, Pismo Beach, and others. Eventually the narrow-gauge railroad extended to Santa Maria, Los Alamos, and Los Olivos to the south and to Templeton to the North. And every time the rail head was extended, the stage line was shortened.

Meanwhile, back in Guadalupe, the Arellanes Adobe lasted for well over a century. It was finally torn down in the 1970s because it was considered beyond repair.

Rancho Nipomo (Named for a Chumash Rancheria)

Rancho Nipomo was established by Captain William Goodwin Dana, a relative of Richard Henry Dana, the author of *Two Years Before the Mast.* Captain Dana could trace his lineage back to 1640, when his family settled in Cambridge, Massachusetts. He shipped off to sea at the age of eighteen, sailing to China, India, and the Sandwich Islands. Eventually he came to the California coast, arriving in Santa Barbara in 1825. He bought a store, then left it in the hands of a friend and continued sailing. He returned to Santa Barbara in 1828, became a Mexican citizen, and married Maria Josepha Carrillo. He then built a schooner at Goleta and did some more sailing.

Dana became a naturalized citizen in 1835 and became eligible for a land grant. He was awarded eleven leagues of land which he named Rancho Nipomo, after a Chumash rancheria. In 1839, he left Santa Barbara and moved to the ranch, where he constructed the famous Dana Adobe.

The adobe was built in a U shape that enclosed a courtyard in the rear. The front wing was one and a half stories. Upstairs there were

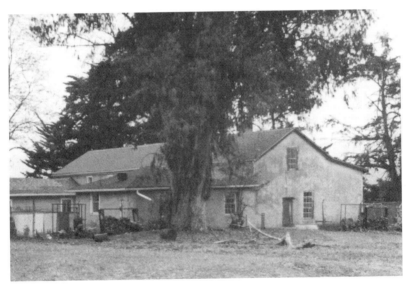

ABOVE: Approaching Rancho Nipomo from the south.

BELOW: The Dana Adobe, built around 1829, as it appears today.

lookouts for poaching bandits and a large dormitory where the ten sons of the family slept.

The Dana Adobe was a stage stop that had a hearty welcome for the weary traveler.

Arroyo Grande

The Arroyo Grande Rancho was granted by the Mexican government on April 25, 1842 to Zafarino Carlona. In 1866 the Rancho was patented by the U.S. Government and was sold to Francis Branch for six hundred dollars. Branch, who had become a Mexican citizen in 1835, was a part of the Carlona family, having married Doña Manuela Carlona. He almost lost the Rancho in 1864, because of a drought, but he regained control and eventually sold a portion of the property to Edgar and George Steele shortly before his death.

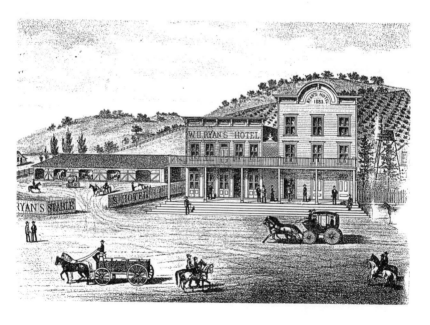

William H. Ryan's Hotel and Stable, Arroyo Grande.

The Steeles established a village and subdivided the remainder of their purchase into smaller farms along Arroyo Creek. The village site had been a Chumash Indian village originally and had later been used for gardens by the San Luis Obispo Mission.

The village of Arroyo Grande in 1878 was described by Loren Nicholson in *Rails Across the Ranchos* as "a thriving place of twelve or fifteen houses, two stores, a saloon, two hotels, a stable, and a black-smith." It also had a stage stop for the Coast Line Stage Company.

Travelers who went north to San Francisco often left the stage at Arroyo Grande and took the Pacific Coast Railroad to Port Harford, where they boarded a steamship and sailed to San Francisco for about $7.30 cabin or $5.80 steerage.

San Luis Obispo

The Mission San Luis Obispo was founded by Father Serra on September 1, 1772, in the "Valley of the Bears," on the busy El Camino Real. In 1845, the California missions were secularized and sold to the highest bidder; the San Luis Obispo mission sold for $510.00.

Mission San Luis Obispo.

At that time the population of San Luis Obispo was approximately 336. After much lobbying and pressure on the government, the missions were returned to the Church in 1859, by which time they were in bad shape. There had been little maintenance or repair done during the period of secularization. In 1868, the buildings of the San Luis Obispo mission were remodeled to look like a parish church. The facade of the church kept the "parish church" look until 1934, when the Mission was restored to its former grace and elegance.

Templeton

Templeton was created on November 18, 1866, by the Southern Pacific Railroad when the line was extended south from Soledad. The Southern Pacific, through some clever and devious dealings, acquired the right of way and created the town where before there had been open fields for raising sheep and cattle. The following description of Templeton is taken from *Crofutt's Overland Tours*, 1888.

Templeton [nine miles south of Paso Robles] is the present terminus of the railroad, 221 miles south of San Francisco.

The country for the last 60 miles, until the railroad was extended through it, was devoted almost exclusively to stock raising, and was held in large tracts—cattle and sheep finding the best range on the coast. When it was known that the railroad would be continued through the valley and extended Southward, these large ranches were sub-divided and offered in small tracts, selling readily for from $25 to $50 per acre, and as the railroad was extended, the towns of San Miguel, Paso Robles and Templeton were laid out on its line, lots sold, and thriving and handsome villages built up. These villages now have large and commodious depots and warehouses, fine brick blocks, hotels, stores, handsome schoolhouses and churches,

The old stage road, still in existence, goes over Cuesta Grade between San Luis Obispo and Santa Margarita.

and many pleasant and stylish residences. At Templeton and Paso Robles expensive and substantial bridges were built across the Salinas River, opening a heretofore unoccupied country to easy access, and developing a large and prosperous business.

So much for railroad propaganda. In fact, the towns mentioned were already successful with the exception of Templeton, which was laid out new. Stagecoaches had been going through these ranches for twenty years by the time the railroad got there, and the towns were doing quite well. In fairness, it must be said however that the Southern Pacific Railroad made them boom.

Rancho Santa Margarita

Stagecoaches began to make regular stops at Rancho Santa Margarita as early as 1851, prior to the arrival of the Coast Line Stage Company. The stage stop was an adobe building called the bunkhouse, which is still standing; it is now covered by a wood siding. If you look carefully across the field to the south you can faintly make out the tracks and ruts of the stage that headed for San Luis

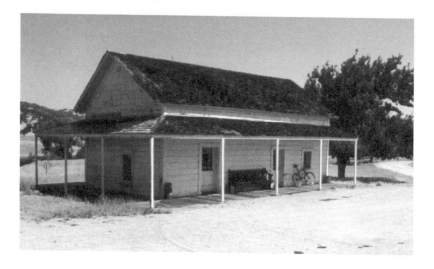

The stage stop at Rancho Santa Margarita as it appears today.
The stage came in from the right and went south across the grassy plain.

Obispo. This stage stop was no longer used after Templeton became the end of the line for the Southern Pacific Railroad.

Southern Pacific Railroad gained the right of way across Rancho Santa Margarita when the Murphys sold half of the ranch acreage to the Pacific Improvement Company for town lots; the package included right of way for the railroad. The other half of the rancho was retained by the Santa Margarita Land Company and divided between Silas Senton et al and the Lewis Foundation.

Paso Robles

The hills and rocky passes of El Paso de Robles (the pass of the oaks) were an ideal spot for stage robbers to practice their profession, relieving the passengers of their gold, jewelry, and other valuables. A story is told of a stage that was robbed in this neck of the woods by a band of desperados. On board were a gambler, a widow with her savings of thirty dollars, a minister and his son. When told to deliver their possessions, the gambler took one of the gang members aside and whispered some instructions in his ear. The bandit then came over to the widow and asked her for her thirty dollars. The widow gave it to him with great regret, and the bandits collected the rest of their haul and left. The preacher chastised the gambler severely for siding with the robbers and helping them to rob a poor widow, whereupon the gambler reached into his boot and took out a wad of bills that equaled a thousand dollars. He then counted out three hundred dollars and handed it to the widow, saying that he always gave a third of his winnings to whoever staked him to the game. The preacher said no more.

In spite of the occasional stage robbery, Paso Robles was a popular stop because of the hot springs there. Travelers would stay overnight and sometimes spend several days there just to relax. At the hot springs was a resort hotel and some cabins. There was also a small store and a Wells Fargo office. The owners during most of the stagecoach days were William and James Blackburn, who purchased the property in 1857.

Here is a description of Paso Robles Hot Springs that appeared in the pages of *The Overland Monthly* in 1871:

Toward the Paso Robles Hot Springs, and beyond it, the level country may be truly likened to an English park, so clean is the sward and so luxuriantly do the trees—white-oak and live-oak—

grow here. On the other side of the springs pine trees, oddly enough, appear among the different kinds of oak; and the effect further on, where the hills are covered with yellow wild oats, and the mountain cypress crowns the highest of them, is beautiful in the extreme. Before reaching the hotel at the springs, my fellow travelers pointed out to me a little redwood building which covered the far-famed hot mud-bath of the Paso Robles. While the horses were being changed, I made my way to the main spring, eager to quaff a goblet of the "health-giving fountain." I looked with profound pity on the men who had gathered around the dark-looking waters, till the place looked like the Pool of Siloam, when the angel was expected to stir its waters. Here, the angel sees ever present; for men turn away, after drinking the horrid stuff, as though they felt sure of being one step nearer to the health they are in pursuit of. Of the healing-power of this bad-tasting water, in cases of rheumatism, neuralgia, and gout, there can be no question. Not only those of our time and generation, who have tried its virtues, speak enthusiastically of it; but what speaks equally loud in its favor is the fact that the clear-sighted *padres* of the mission *régime*, and the old Indians and Californians, held it in high esteem.

San Miguel

The Mission San Miguel was established between the missions in San Antonio and San Luis Obispo to better serve the Indian population. Construction was begun in 1795 and the first mass was held in 1798. In 1845, when the government decided the missions had too much land and power and ordered secularization, the Mission San Miguel was sold to the highest bidders, who were Petronelo Rios and William Reed. Reed moved into the mission, where he and his family met a tragic end.

The Caledonia adobe as it looks today from the stage road.

Rios built a house a quarter of a mile down the road. This adobe, which is still standing, was eventually named the Caledonia, and from 1860 to 1886 it served as an inn and stage stop on the road from Los Angeles to San Francisco. It was a busy stop until the railroad was completed. The pools of the Salinas River washed the dust off many a weary traveler, and the second-story balcony provided an enjoyable view of the cottonwoods and the river.

Ann Nigerian Hebel of Carpinteria, who grew up in San Miguel and lived in the Caledonia, gives us this description of the old adobe:

The adobe ranch house was built by Señor Petronelo (Petronillo) Rios some time between 1830 and 1848 with the aid of Indian friends. Its thick adobe walls were covered with a hard white plaster of lime, river sand and animal hair mixture. The porch and balcony across the front was typical Monterey architecture—a large room with a staircase going up to the

second floor had a door to a one-story kitchen that had an outside door in back. The other rooms only had outside entrances from the porch in front and directly from the yard in back, with no windows. The upstairs had two large rooms which went the length of the house, from back to balcony, and two smaller rooms on the south end. There were niches in the thick walls of the large rooms where statues were placed. The interior of the niches was a beautiful blue and I loved to put bouquets of wild flowers in them. The attic was entered from one of these large bedrooms by a ladder. The rough pole rafters were tied in place with leather thongs. Pigeons had established a colony up there and it was my job to catch the squabs for eating.

Pleito and the Road to Jolon

The stage trail from San Miguel to Jolon is hard to follow because of several changes that have taken place since stagecoach days. During the 1940s, when the Hunter Liggett Reservation and Camp Roberts were both developed, many of the roads in the valley were changed to meet the needs of military vehicles and the fast transport of troops. As for Pleito, which was one of the stage stops, it's at the bottom of man-made Lake San Antonio. Nacimiento, another stage stop, is at the bottom of Lake Nacimiento.

Our best guess is that the road left San Miguel and went west into what is now Camp Roberts, along the north side of the Salinas River, until it reached Pleito. It then continued on the north side of the Salinas and crossed the river about four miles south of Lockwood, on what is now the Hunter Liggett Military Reservation, then followed the Salinas a few more miles before turning north toward Jolon.

It was a beautiful drive, according to this description from the *Overland Monthly* in October of 1871:

The Dutton Hotel, on Jolon Road, as it appeared in 1965.

The country on this side of the Pleito Ranch, and just beyond, is pleasant and fresh-looking, open and dotted with white and live oak, whose dark branches are decorated with arabesques and garlands of the pale-green hanging moss. At the foot of the hills flows the Salinas River, its course marked by the willow and sycamore; on the hillsides are large herds of sheep, and in the slopes and ravines between are more sheep. Skillfully the driver winds along at the foot of the hills, making an occasional sudden and unavoidable dive into the gulches which the winter waters have torn.

Jolon

Jolon, called "the valley of the dead oaks" by the Indians, is located five miles south of the San Antonio Mission. The town had two hotels, the Dutton and the Tidball. The Duttons were Republicans and the Tidballs Democrats, which meant the mail stop changed with the

fortunes of the two political parties. The Republicans had the controlling party during most of the stagecoach era, and the Dutton Hotel was the major stage stop.

The Dutton was a two-story adobe with overnight accommodations, a bar, and a dining room. A huge grape arbor draped itself over about half of the building, and many a romance got its start under that arbor. There are stories of babies born in the hotel rooms of the Dutton. The hotel was a lively place, especially at rodeo and fiesta times; but just about any time you went into the bar you could find miners, ranchers, and travelers wetting their whistles and loosening their tongues, swapping yarns about the bandit Vasquez, boasting about their love affairs, or telling tall tales about lost gold mines.

The town of Jolon grew to a place of some size. In addition to the two hotels, there were three saloons, two blacksmith shops, two stores, a large dance hall, a church, and a jail. There was even a Chinatown, where the Chinese domestics lived.

William Randolph Hearst purchased the land around Jolon and the town went into a decline. When the Army took over the land for the Hunter Liggett Reservation, Jolon became a ghost town. All that remains today are a few crumbling walls of the Dutton and some roads that are hard to find and go nowhere. The old stage road no longer exists; or, if it does, it's hiding.

◄ Trabuco Vasquez, the California Robin Hood ►

Trabuco Vasquez was known around Jolon as a dashing, fun-loving, and generous man, and he could often be seen drinking at the Dutton Hotel. More than once he was there drinking when the stage showed up with the upsetting news that they'd been held up at La Cuesta, the pass between King City and Jolon. Vasquez would

express his outrage and would buy drinks for those passengers who had been robbed. If a posse was raised to hunt for the outlaws, Vasquez would sign up.

But after the stage had moved on, Trabuco Vasquez would go about his real business, sharing with his friends the wealth that he himself had robbed from the stage—because he was that masked scoundrel of La Cuesta.

It all began when Trabuco was seventeen years old. There was a fight in a Monterey dance hall with two gringos who had crashed the party and were being obnoxious with the ladies. When the gringos cut in once too often, a free-for-all broke out. The lamp was shot out, a knife was flashed in the moonlight, and one of the gringos lay dead on the dance hall floor. Vasquez fled to the hills. Eventually he was captured and tried in a court of law, but he was acquitted because no evidence was produced that could prove him guilty. However, from that time on, whenever any mischief happened in the gringo community, Trabuco was always suspected, hauled into court, and forced to tell where he'd been when the act was committed.

His hatred for the gringos grew until finally he made a vow to his mother that he would get even—by committing some of the crimes of which he'd been accused.

Vasquez rustled cattle and sheep and then gave them to the Indians for food. The Indians always protected him; once he hid under the billowing skirt of an Indian woman while the sheriff and posse searched for him, and another time he crawled into the bedclothes of a California woman who had just given birth. He didn't always get away; in fact he spent some time in San Quentin for stealing horses. But when he got out, he got back to work, robbing from the gringos and giving to his friends. In time he formed a gang, which included Three-Finger Jack Garcia, another famous California bandit, and they robbed so many stagecoaches that they lost count of the number of holdups.

Trabuco especially enjoyed being generous with the ladies. He bought (or otherwise acquired) earrings and bracelets and gave them to his adoring señoritas. One of his lady friends left her husband and lived with Vasquez and bore him a child. Unfortunately, the romance soured and she betrayed him. Lawmen showed up at her house while he was eating there, and although Vasquez tried to escape through the window, he was captured. He was tried and sentenced and hanged.

The many Californian and Indian friends of Trabuco Vasquez burned candles on the altars of their churches, mourning the loss of their provider and friend, the California Robin Hood.

Lowe's

In the middle of the King Ranch pasture were an inn and post office, both built by Elias Howe, the son of the inventor of the sewing machine. Howe Junior had come around the Horn and had settled in California. He and his cronies would gather on the porch to watch for the stagecoaches approaching. In true California style—meaning they would take advantage of any occasion to celebrate—they would place bets on which stagecoach would arrive first. When the winner arrived, the locals would join the driver in the bar and celebrate the victory. The celebrations would continue long after the stage had left.

Los Coches

The Los Coches stage stop was at the crossroads to the Soledad Mission and Paraiso Hot Springs, on land that was granted by Mexican Governor Juan Alvarado to Maria Josefa Soberanes in 1841. Her father, Feliciano Soberanes, and her uncle, Mariano

Soberanes, had received other land grants earlier, but Los Coches was built by Maria. The Soberanes family connection with this land dates back to the time of Portolá's expeditions up and down California; Maria's grandfather, José Soberanes, accompanied Portolá at the age of sixteen, and as he rode through the Salinas Valley he dreamed of living there. His father-in-law received the first grant in the Soledad Mission area. Young José worked hard to prove up to his land, but he died before he could prove title to all the land. His widow moved to Monterey and her son Feliciano took over the valley rancho. Eventually Feliciano and Maria proved ownership of 115,000 acres.

Maria Josefa Soberanes married William Brunner Richardson in 1839. Richardson was a hard-working tailor from Baltimore, Maryland, who had come to California in 1833. When Maria received the grant in 1841, the Richardsons decided to build an adobe on this ranch. The Los Coches adobe was built in 1843, and a wooden addition was built in 1848. The adobe became the stage stop, and William Richardson was the postmaster, serving the ranchers for miles around.

The rancho served as a stage stop from the time that stages were running up and down the Salinas Valley and north to San Francisco and as far south as Santa Margarita Rancho. The Coast Line Stage Company made stops from 1866 until 1869, when the Southern Pacific Railroad extended their rail line to Soledad.

The State of California now owns the property. The ten acres and the Adobe were a rest stop on the El Camino Real (U.S. 101) until recently. The historic site is now operated by the City of Soledad.

Natividad

Stagecoaches first reached the town of Natividad, north of Salinas, back in 1851. Passengers would leave San Francisco, change stages

in San Jose, then change again in Natividad to continue their trip to Monterey or Santa Cruz. Natividad remained an important stage stop until 1869, when railroad service was extended to Soledad. Thereafter, only local stages were profitable, because the area was so well served by railroads.

During its heyday, Natividad boasted one hotel, one store, one billiard table, one bar, and ten hitching posts. The old hotel, built in the late 1850s or early 1860s by John W. Patton, has long since been torn down, but the old saloon remained standing until the 1960s.

The Road to San Juan

Northbound coaches would leave Natividad on what is now called the "Old Stagecoach Road" to cross the San Juan Mountains. It was a steep climb, and at some points the mail passengers got out and walked, pushed, and did whatever it took to get the coach over the top. The route was changed in the spring of 1867 when Coast Line Stage Company (San Juan to Los Angeles Stage Line) completed a new easy grade across the San Juan Mountains. This new route followed the old El Camino Real to the top of the ridge, then went northward along the western rim of the canyon and finally down into San Juan Valley, one mile south of San Juan Bautista. The road still exists and is paved with gravel, but it is now closed to through traffic.

The "Old Stagecoach Road" followed the path that Father Serra walked in 1779, on his way from Carmel Mission to Santa Clara. It was not, however, the first road over the San Juan Mountains. The first was an Indian trail that went over the grade and ended somewhat south of San Juan. The second went up Crazy Horse Canyon over several ridges to the San Juan Valley. A fourth road was built in 1915 and is now known as the Salinas Grade Road. It's not particularly important historically, but it makes up for that in terms of

Except for some farming, the landscape is much the same today as
when the padres traveled from Mission Carmel to San
Juan Bautista on their way to San Jose.

beauty and wildness. One can go for miles without passing a farm-
house, and in the spring it is worth the thirty-minute drive to see the
green grass and wildflowers by the acre.

San Juan Bautista

This lovely tourist town surrounded by vineyards, the home of one
of the California Missions, and the scene of the Hitchcock movie
"Vertigo," was a popular stop in stagecoach days. The Mission was
established in 1797, and the town grew over the years, becoming a
center of farming and sheep ranching, but it was the stage lines that
really put the place on the map. By the early 1860s San Juan was one
of the busiest stopping places on El Camino Real, with settlers of all
kinds passing through—miners from north and south on their way

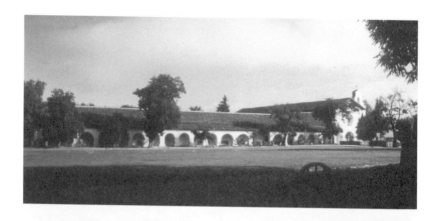

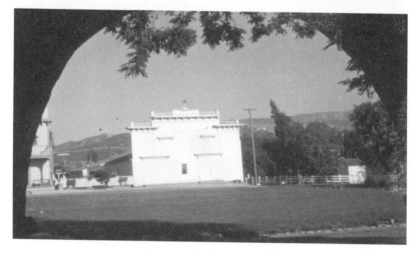

ABOVE: Mission San Juan Bautista, established 1797.

BELOW: View through the mission arch of the stage barn from which more than ten stage companies operated, including Coast Line Stage Company.

Office of the "Stage Barn."

to better claims, and newcomers to California, looking for the homes they'd dreamed of as they traveled across the plains. By the late 1860s, there were no fewer than seven stage lines that used San Juan Bautista as a stopover.

It was a thriving transportation hub. The stage would roll into San Juan about five-thirty in the afternoon, from either direction, or from both. The driver would leave his passengers at the Plaza Hotel and then take his stage over to the stage barn, where the horses would be changed and groomed for their next journey. The

ABOVE: Horses would be placed in these stalls, and when the stage drove in they would be harnessed to a new coach and ready to travel on fifteen miles to the next stop.

BELOW: The blacksmith shop, where wheels and wagons were repaired and horses shod.

The Plaza Hotel, where stage passengers could wash up, quench their thirst, have a good meal, make plans to stay overnight, or wait for the next coach to take them on the next part of the journey.

passengers would dine at the Plaza or at other establishments around town. After the meal, some passengers took rooms for the night, and others got back on the stage, or other stages, and settled in for a long, all-night ride.

Off they'd go, into the night, year round, in all kinds of weather. They grumbled perhaps about the hardness of the seats and the roughness of the road, and they worried sometimes about bandits and floods, but they were fortunate passengers indeed to be alive and on the move in the days of California's Coast Line Stage Company.

⊰ Epilogue ⊱

The Last Stagecoach in California

California saw many changes over the course of the second half of the nineteenth century, and those changes can be chronicled in the transformation of transportation. The population explosion that began with the discovery of gold continued for decades, as oxen-drawn wagons and then steel rails brought thousands of people across the prairies and the deserts to the Golden State. By the twentieth century, California was a dynamic force in the nation's economy, and was the site of a prosperous land boom.

Within the state, the means of transportation changed as well, from horse trails and ships along the coast to stagecoaches inland, which eventually were replaced by railroads and, in due time, by the automobile.

Although it operated for only a few decades, the Coast Line Stage Company was an important contributor to the growth of California's prosperity during the latter half of the nineteenth century. From the mid-1860s to the turn of the century, it provided a vital link for travel up and down the coast of California, enabling people to travel relatively comfortably from Los Angeles to San Juan Bautista, with connections to San Francisco and beyond.

But in time the railroads took over the role of transporting people

up and down the coast, just as automobiles would inherit that role in the twentieth century. The last stagecoach to go over the San Marcos Pass was in 1901, ending the Coast Line Stage Company's service up and down the California coast.

However, stagecoaches in California still traveled here and there on shorter runs for another decade. Mattei's Tavern in Los Olivos, which we visited in the journey of this book, ran a stagecoach right up until 1911, bringing customers over the hills from Gaviota. When that stagecoach finally stopped, the era of stagecoaching in California was a thing of the past.

⤜ Time Line ⤛

1849 The Gold Rush

1851 The San Jose Line extends to Natividad, Monterey Co.

1854 Phineas Banning crosses the Tejon Pass out of San Fernando Valley

1857 Overland Stage Line established from San Diego to San Antonio, Texas

1858 Butterfield Stage Line from Los Angeles to San Francisco, via Tejon Pass and Central Valley

1859 Ezra Drown discusses road from Los Angeles to San Luis Obispo

1860 James Thompson builds that road

1861 Santa Susana Pass (Devil's Slide) created

1862 "Good roads" completed from Los Angeles to San Juan Bautista

Regular stagecoach service between these points begins

Gaviota Pass widened, Conejo Grade developed

1864 William Lovette campaigns for Lincoln by stagecoach

Lovette lands mail contract

1867 Flint Bixby and Company takes over Coast Line Stage Company

1868 Bixby Line offers service three times a week

1873 Rail service ended at Soledad

1875 Route changed back to Conejo Pass

Route changes in Santa Barbara County

1876 Southern Pacific arrives in Los Angeles. Most stage business stops.

Central Coast Railroad extends to Los Alamos

1878 Taylor & Buckley buy the line from Flint Bixby

1881 Pacific Coast Narrow Gage, San Luis Obispo to Arroyo Grande

1882 Pacific Coast Narrow Gage extended to Santa Maria and Los Alamos

1886 Rail extended to Templeton, where it met stage

1887 Pacific Coast Narrow Gage extended to Los Olivos

1901 Last stage goes over San Marcos Pass

1904 Southern Pacific completes coast route to Los Angeles via Point Conception

End of stage coaching in up and down the coast

1911 Mattei stops the stage from Gaviota to Mattei's Tavern, thus bringing an end to stagecoaching in California

⇥ Bibliography ⇤

Allison, Bill. "Driver Recalls Old Stagecoach Races Over San Marcos." *Santa Barbara News-Press*, July 30, 1939.

Anon. *Bixby Land Company: a Continuing Family Endeavor.* Historical Society of Southern California, 1987.

_____. *Crofutt's Overland Tours.* Arthur H. Day & Co., 1888.

_____. *Dictionary of California Cities and Towns.* San Luis Obispo, 1916.

_____. "Dutton Hotel: A Ghost from the Past." *The Rustler*, May 6, 1971.

_____. *El Pueblo: Los Angeles Before the Railroads.* Security Trust and Savings Bank, 1928.

_____. "Following a Stage Route: A Self-Guided Tour by Car, Thousand Oaks to Los Olivos." Unpublished paper prepared by M.H.S. for the Docent Council of the Stagecoach Inn.

_____. *The First Los Angeles City and County Directory, 1872.* Reproduced in facsimile by Ward Ritchie, with commentaries by J.M. Gunn. Ward Ritchie Press, 1963.

_____. "Gaviota and San Marcos Passes." *PG&E Progress*, April 1966.

_____. "Guadalupe Rancho." Unpublished paper.

_____. "Guadalupe: The Most Cosmopolitan Small City in America, As Seen and Written for *Westways*." Automobile Club of Southern California.

_____. *History of Cold Springs.* Cold Springs Tavern.

_____. "A Letter to W.E. Lovett and Co., 1923." *Historical Record and Souvenir,* Pioneer Society of Los Angeles County, 1966.

_____. "Los Coches Rancho." *PG&E Progress,* December 1964.

_____. *Overland Stage.* Wells Fargo Bank, 1987.

_____. *Panorama of Southern California.* Title Insurance and Trust, 1953.

_____. "Re: Wells Fargo Agents at Jolon." Unpublished memo to Janice Smith, Wells Fargo Banking Service Officer, King City, July 31, 1979.

_____. "Saga of the Central Coast." *Central Coast Magazine,* 1994.

_____. *Santa Barbara: A Community History.* Security-First National Bank, 1930.

_____. *Santa Barbara County.* Automobile Club of Southern California, 1990.

_____. *Southern California 100 Years Ago, Volume II.* Sun Publishing Company.

_____. *Southern Pacific's First Century.* Pamphlet, 1955.

_____. "Subject: 'Old Stage Road' Route from King City to Jolon." Unpublished Memo from Department of Parks, County of Monterey, to Dennis L. Wardell.

_____. *Spirit of the Big Yellow House.* Emily Publications, 1995.

_____. *Stagecoach Inn Museum.* Pamphlet. (Source unknown.)

_____. *The Story of San Luis Obispo County.* Title Insurance and Trust, 1960.

_____. *The Story of The San Fernando Valley.* Title Insurance and Trust, 1961.

_____. *The Story of Ventura County.* Title Insurance and Trust, 1955.

_____. "Tale of Two Villages." *Press Telegram,* April 3, 1928.

_____. "Ten Commandments for Stage Passengers." *51st Los Alamos Days Annual,* 1997.

_____. "Tropical California." *The Overland Monthly,* October 1871.

_____. "William Edward Lovette: California Pioneer." *Padre*. December 5, 1937.

Banning, George Hugh. "Stage Wheels Over Padres' Trails." *Westways*, July 1934.

Bauer, Helen. *California Rancho Days*. California State Department of Education, 1957.

Beck, Warren A., and Ynez D. Haas. *Historical Atlas of California*. University of Oklahoma Press, 1974.

Bell, Major Horace. *Reminiscences of a Ranger*. Wallace Hebberd, 1927.

Brewer, William H. *Up and Down California: 1860-1864*. University of California Press, Ltd., 1866.

Bryant, Edwin. *What I Saw in California*. University of Nebraska Press, 1985.

Caldwell, Jayne Cravens. *Carpinteria As I Saw It*. Papillon Press, 1979.

Chesnut, Merlyn. *The Gaviota Land*. Fithian Press, 1993.

Committee for the Preservation of Chapel of San Ramon. "Adobes of the Sisquoc Valley." Unpublished paper.

Dana, Richard Henry. *Two Years Before the Mast*. Ward Ritchie Press, 1964.

Davison, Grace L. *The Gates of Memory: Reflections of Early Santa Ynez Valley*. Santa Ynez Valley News, 1955.

De Turk, Charles, Hugo Fisher, and Fred Jones. Unpublished notes. San Juan Bautista State Historic Park.

Dudley, Stephen. "The Bixby Family Guide." Unpublished paper, 1966. Rancho Los Cerritos Historic Site.

Elliott, John F. "Rancho El Encino History." Unpublished paper.

Fisher, Anne B. *The Salinas: Upside-Down River*. Rinehart & Company, 1945.

Flint, Dorothy. *Escarpment on the San Andreas: The Probing of a California Heritage*. 1979.

Flint, Marjorie C. "Coast Line Stage Company." *Western Express,* October 1962.

Flint, Thomas Jr. Unpublished letter dated March 20, 1931. Rancho Los Cerritos Historic Site.

Gordon, Max. "Stagecoaches: They Put the Valley on the Map." *Salinas Californian,* July 7, 1980.

Hall-Patton, Mark. "Tiny Stage Lines Also Served the County." *South County Telegram-Tribune.* November 29, 1990.

Halsted, A.S., Jr. "Notes Tell of Rincon Trip by Stagecoach a Century Ago." Letter to *Herald,* February 4, 1960.

Hamilton, Geneva. *Where the Highway Ends.* Padre Productions, 1974.

Hardesty, Betty. "Signs of the Times." Newspaper article. (Source unknown.)

Hebel, Anna Nygren. "The Old Caledonia on El Camino Real." Unpublished paper.

Hill, Laurance L. *La Reina: Los Angeles in Three Centuries.* Security Trust and Savings Bank, 1929.

Hollister, J.H. "Stage Drivers and Swampers: Brave Men of Early Day Transit." *The Daily Press* (Paso Robles). October 8, 1976.

Hoppe, Gary Keesey. "Pico House Was L.A.'s Pride." *Fedico Reporter,* October 1995.

Hubbard, Jean. "Pioneering Californians Found Fun Even in a Stage Ride." *Five-Cities Times Press.*

Hunter, Vickie, and Elizabeth Hanna. *Stagecoach Days.* Lane Book Company.

Jorgenson. *San Fernando Valley Past and Present.*

Keefer, Frank. *San Fernando Valley.* Stillman Printing Company, 1934.

Lompoc Valley Historical Society. "Roads to Lompoc, Parts I & II." *Lompoc Legacy,* Spring, Autumn 1975.

McDonald, Christina. "Stagecoach Days in the Conejo." Unpublished paper, 1987.

MacDonald, Craig, Pacific Telephone Company Public Relations. "Just Another Santa Claus Legend." Unpublished paper.

Merrill, King. "Historic San Marcos Pass." *Lompoc Record*, August 31, 1977.

Miller, Kathleen L. "The Temple Block: A Core Sample of Los Angeles History." *Journal of the West*, April 1994.

Mylar, Isaac L. *Early Days at the Mission San Juan Bautista*. Ward Dancer Press.

Newmark, Harris. *Sixty Years in Southern California: 1853-1913*. Zeitlin & Ver Brugge, 1970.

Nicholson, Loren. "Old Postcards: An Elegant 1890s Social Center." *Senior*, March 1989.

_____. *Rails Across the Ranchos*. California Heritage Publishing Associates, 1993.

Outland, Thomas. *Stagecoaching on El Camino Real*.

Pardee, Don. "The History of the Pacific Coast Railway." Unpublished paper.

Pedersen, Roy H. Unpublished letter to Clyde Trudell. San Juan Bautista State Historic Park.

Penn, Martin. "Four Roads to San Juan." Newspaper article. (Source unknown.)

Phillips. "John Waugh, Stage Coach Driver." Unpublished paper. Santa Barbara Historical Society, 1927.

Pierce, Marjorie. *East of the Gabilans*. Western Tanager Press, 1981.

Poett, A. Dibblee. *Rancho San Julian*. Fithian Press, 1991.

Powell, L. "William Benjamin Foxen." Unpublished paper, 1973.

Rasmussen, Cecilia. "L.A. Scene: The City Then and Now." *Los Angeles Times*, August 2, 1993.

Riesenberg, Felix, Jr. *The Golden Road*. McGraw-Hill Book Company, 1962.

Roberts, Lois J. "From Fort Hunter Liggett History." Unpublished paper.

Robinson, W.W. *Land in California*. University of California Press, 1979.

_____. *Los Angeles from the Days of the Pueblo*. California Historical Society, 1981.

Rouse, Stella Haverland. "Olden Days: Horses Posed Big Problem in 1847." *Santa Barbara News-Press*.

_____ "Olden Days: Masked Man Controlled Stage Coach Routes." *Santa Barbara News-Press*.

_____. "Olden Days: Stage Robber Ended Colorful Career Here." *Santa Barbara News-Press*, August 17, 1969.

_____. "Olden Days: Stage Coach Offered Rough, Dangerous Ride." *Santa Barbara News-Press*.

Santa Maria Historical Society. *This Is Our Valley*. Westmorland Press, 1959.

Schley, Wolcott. "A Short History of the Santa Ynez Valley." *Solvang Guest*, Summer 1993.

Smith, Sarah Bixby. *Adobe Days*. Valley Publishers, 1974.

Stockton, Georgia. *La Carpinteria*. Carpinteria Valley Historical Society, 1960.

Storke, Thomas M. *California Editor*. Westernlore Press, 1958.

Tompkins, Walker A. *Goleta: The Good Land*. Goleta Amvets/*Santa Barbara News-Press*, 1966.

_____. *It Happened in Old Santa Barbara*. Santa Barbara National Bank, 1976.

_____. *Mattei's Tavern: Where Road Met Rail in Stagecoach Days*. Olive Press Publications, 1986.

_____. *Santa Barbara History Makers*. McNally & Loftin, 1983.

_____. *Santa Barbara Yesterdays*. Heritage Press, 1962.

_____. *Santa Barbara Yesterdays*. McNally & Loftin, 1966.

_____. *Stage Coach Days in Santa Barbara County.* McNally & Loftin, 1982.

Ventura County Historical Society. *Ventura County Historical Society Quarterly*, May 1968.

Vischer, Edward. "Notes on a Trip by the Southern Overland." *Pictorial California*, June 3, 1865.

Walleson, Olive E. *Mysteries and Legends of Jolon, California.* 1985.

Wheelwright, Jane Hollister. *The Ranch Papers.* Lapis Press, 1988.

Wilson, Neil C. *Treasure Express.* Rio Grande Press, 1987.